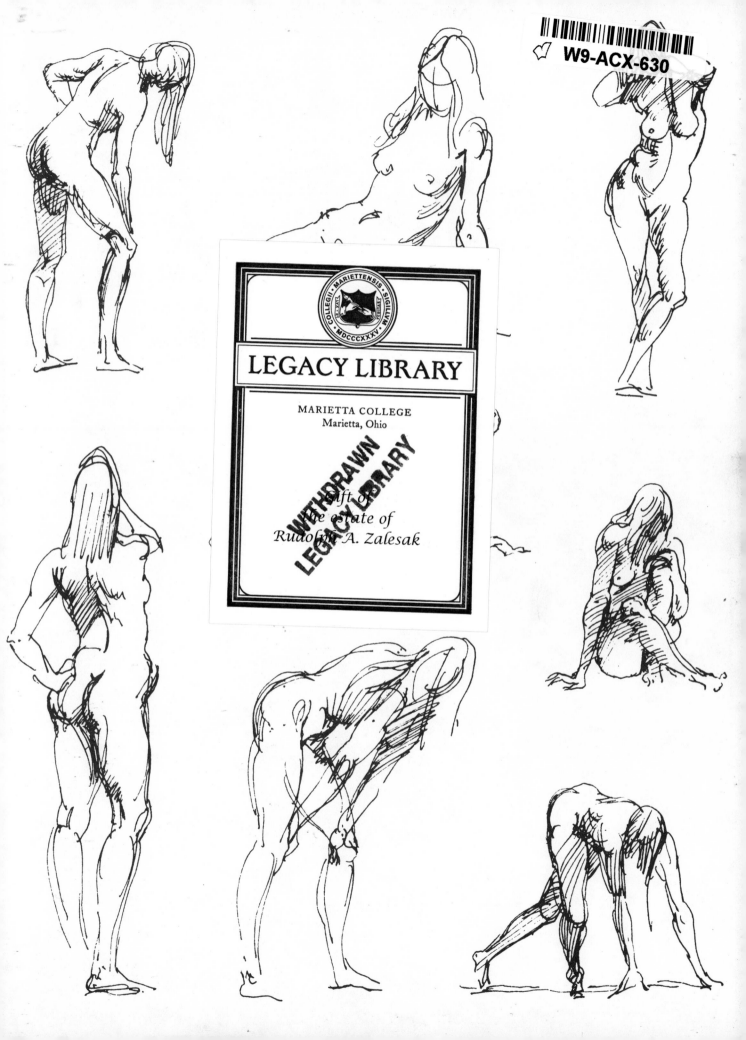

DRAWING THE FEMALE FIGURE

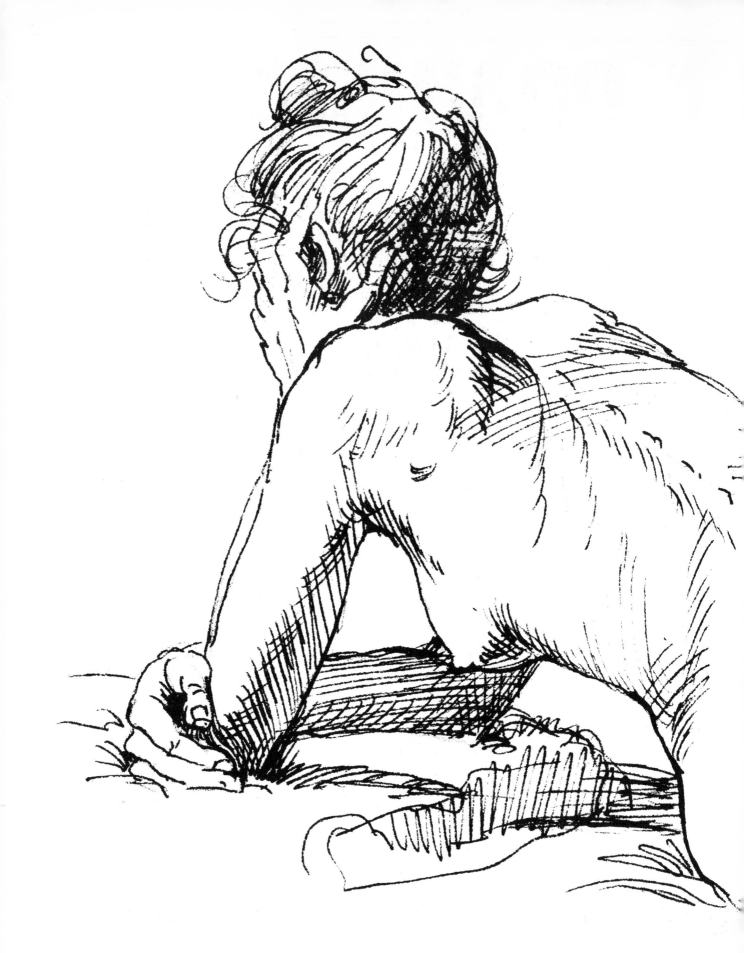

DRAWING THE FEMALE FIGURE

BY JOSEPH SHEPPARD

WATSON-GUPTILL PUBLICATIONS/NEW YORK PITMAN PUBLISHING/LONDON

Copyright © 1975 by Watson-Guptill Publications

First published 1975 in the United States and Canada by Watson-Guptill Publications
a division of Billboard Publications, Inc.
One Astor Plaza, New York, N.Y. 10036

Library of Congress Cataloging in Publication Data
Sheppard, Joseph, 1930–
 Drawing the female figure.
 1. Figure drawing. 2. Women in art. 3. Nude in
art. I. Title.
NC765.S43 743'.44 75-15872
ISBN 0-8230-1370-7

Published in Great Britain by Sir Isaac Pitman & Sons Ltd.
39 Parker Street, London WC2B 5PB
ISBN 0-273-00092-6

Manufactured in U.S.A.

First Printing, 1975

To my son, Jon

CONTENTS

INTRODUCTION

Although I paint and sculpt just about every subject, my real joy is in, and my best work is of, the human figure. So it was very natural, when I started to teach ten years ago, that I should teach a course in life drawing.

My life classes last all day, from 9:30 in the morning to 3:30 in the afternoon. In the morning we have quick, two-minute poses then a series of twenty-minute poses. After lunch I give a half-hour lecture on anatomy, and during a semester I cover the bones of the skeleton and the muscles. (For additional help with drawing the figure, I suggest my book *Anatomy: A Complete Guide for Artists*, which I use as a text.) We then start drawing from the model as we did in the morning, with quick and then longer poses. For homework I have the students copy Old Master drawings, especially those of Michelangelo, Dürer, da Vinci, and Rubens, that have good examples of the anatomical region that we have covered in the anatomy lesson for that day.

When my students first come into the class, they form a semicircle around the model stand that sits against one wall. Focused on the model stand, about ten feet off the floor and slightly in front and on the left, I have a spotlight. Controlled, natural light would be softer, and preferable, but our particular setup doesn't permit it. The important thing in lighting is to have just one source. This creates the most effective light and shadow for rendering the illusion of three dimensions.

The students sit or stand at least fifteen or twenty feet away from the model. Sitting any closer than that would give a distorted view, much as a camera would, making any part of the figure projecting out toward you appear too large. Also, if a model were in a standing position, you would be looking down at her feet, be at eye level with her belly, and looking up under her head, which would give the whole body a bowed look.

I start the model off with ten two-minute poses as limbering-up exercises for her and for the class. The class is encouraged to draw the entire figure, including the hands and feet, in the two minutes. To complete the figure in this time, I recommend drawing the figure small, four to ten inches high. Most of the Old Master drawings were small, which enabled the artist to see at a glance whether he had the attitude and proportion correct.

In the beginning, the student can hardly get the attitude down, but after a few weeks he not only has time for that but finds time to render light and shade too.

Because each student has a different view of the pose, I never teach the class *en masse*. I walk around and talk to each student individually about his particular view. In one view, an elbow might be an important factor and we discuss it anatomically. In the next view the elbow might be hidden, but in this drawing the stomach might crease in a certain way, and I'll explain that. One time I'll speak of anatomy, another time, proportion. Or attitude. Or rendering. Even though the model is in the same pose for each student, each viewpoint offers a different important aspect to discuss.

Many of the drawings in this book were drawn in the life class, working along with the students. They were drawn in either two-minute poses or twenty-minute poses. I selected them from about ten years' work.

The drawings are arranged in the book first by position — standing, sitting, kneeling — and then by viewpoints — front, back and side. I approach each drawing in much the same way as I would if I were teaching my class. Each drawing dictates what should be said about it. In one section, for example, I might talk about a wrist that's prominent and then not mention the wrist again until another chapter, where it again becomes important.

What happens is that in the course of discussing the many positions and viewpoints shown in the book, most of the important aspects of drawing the female figure are covered: anatomical points, proportion, attitudes and weight distribution, rendering, variations and types, foreshortening, the figure in motion, and whatever else might arise.

It is my hope that this book will offer an insight into the procedures of drawing from life — how to look at the model, what to stress to make a compelling drawing, how to compose the figure. It is only through drawing from life, ideally backed up by studying anatomy and copying Old Masters, that a student will gain the solid foundation needed to render the figure with authority.

I
RENDERING FORM IN LIGHT AND SHADE

Human body forms are either cylindrical or spherical. Angular planes in the body always end in soft, rounded edges. The rendering of the torso or of a finger presents the same problems and has the same solutions.

If we take a sphere and light it from above and to one side, we create several areas of light and shade. The general area of light is called the *halftone*; it is the color of the object. In the center of the halftone nearest the light source is the *highlight*. The area away from the light is the *shadow*. The shadow is darkest next to the halftone: this is called the *accent of the shadow*. Toward the outside of the shadow area the light bounces off another form (or off the background) back to the sphere: this is the *reflection*. The reflection is never as bright as the halftone. When the sphere touches or is near another object, it throws a *cast shadow* upon it. The cast shadow is darkest next to the object that is casting it; it starts dark and then lightens and diffuses as it pulls away. In order of value from light to dark, we have highlight, halftone, reflection, cast shadow, shadow accent, and beginning of the cast shadow.

The Old Masters discovered that one light source was the perfect light. Most of the painters used a light that would give them three-quarters light and one-quarter shadow on an object. To study this, look through reproductions of Old Master portraits. Carravagio used one-quarter light and three-quarters shadow for a dramatic effect. A few exceptional painters such as Rubens and Velázquez brought the light around to an almost frontal position, still from above, with only a fraction of shadow. This made the rendering of form more difficult, but it gave them more color. The impressionists used full light, which gave them a total area of color but sacrificed three-dimensional form.

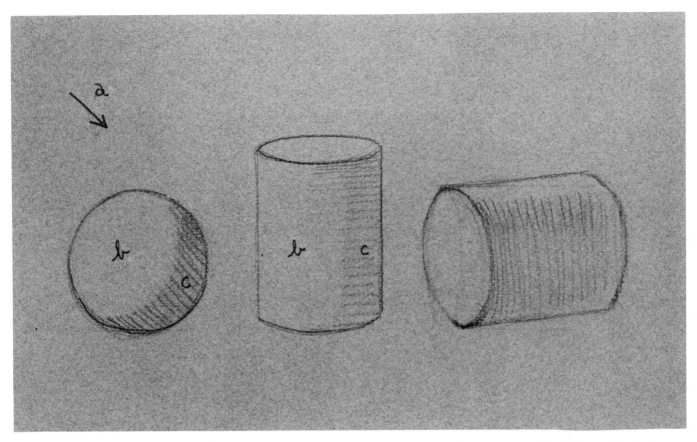

One light source (a), high and to the side, creates two-thirds light (b) and one-third shadow (c). A somewhat different distribution of light and shadow appears on the cylinder when it's lying on its side (at right).

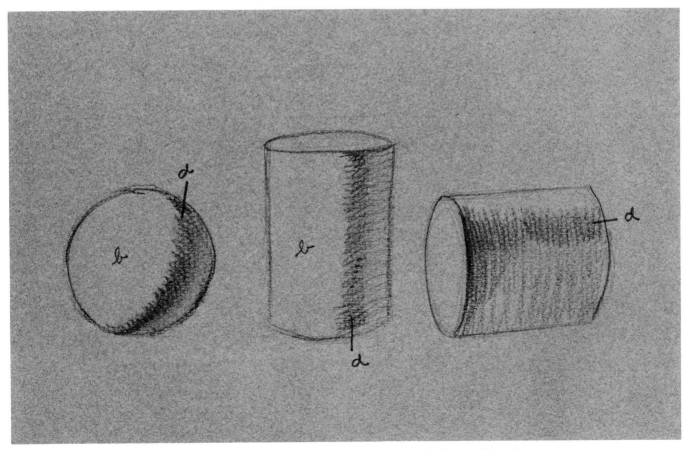

The shadow accent (d) is the darkest part of the shadow and is always next to the halftone of light (b).

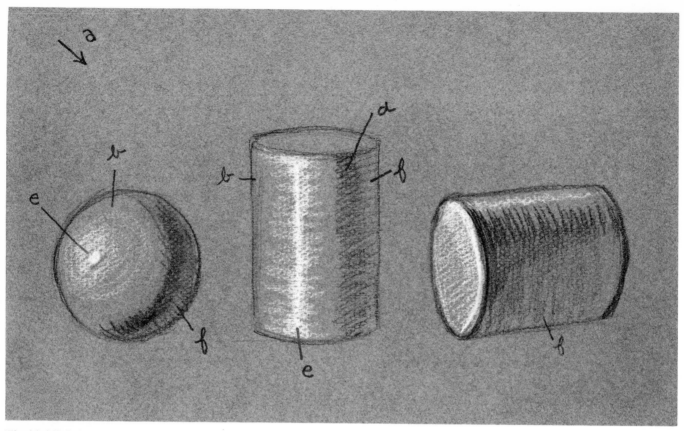

The highlight (e) is in the center of the halftone of light (b). The lighter part of the shadow is the reflection (f).

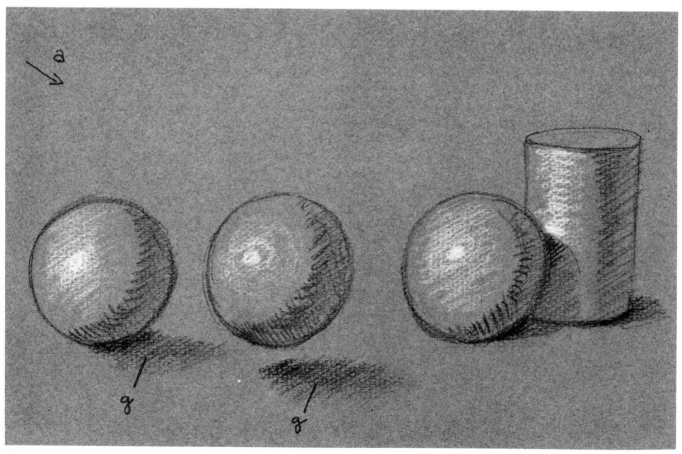

The cast shadow (g) is always darker next to the object casting the shadow. The cast shadow determines where the object sits in space and how it is related to other objects.

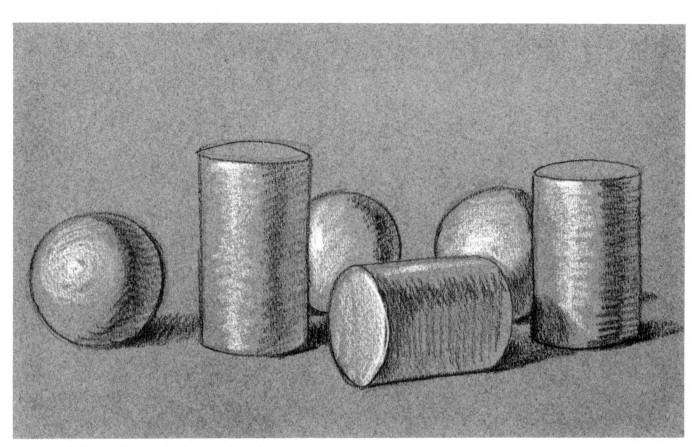

A group of objects. The cast shadows explain where objects are in relationship to each other.

II
PROPORTION

Proportions vary from person to person. However, the classic Greek and Renaissance figure is eight heads in length, the head being used as the unit of measure. The Mannerist artists created elongated figures of nine or more head lengths. In nature the average height is seven-and-a-half heads. The eight-heads-length figure seems by far the best: it gives dignity to the figure and also seems to be the most convenient for measuring.

The classical female figure measured one-and-a-half heads across the shoulders and two heads across the hips. The modern ideal figure is more trim and has narrower hips.

Certain bones project on the surface of the body and become helpful "landmarks" in measuring proportion. These bones are always next to the skin. On a thin body they protrude, on a heavier one they show as dimples.

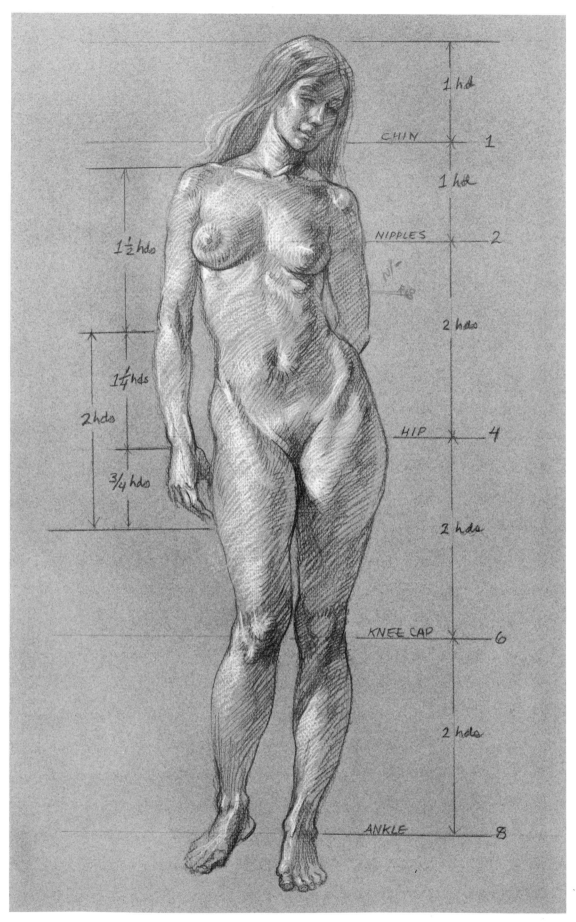

Standing, front view.

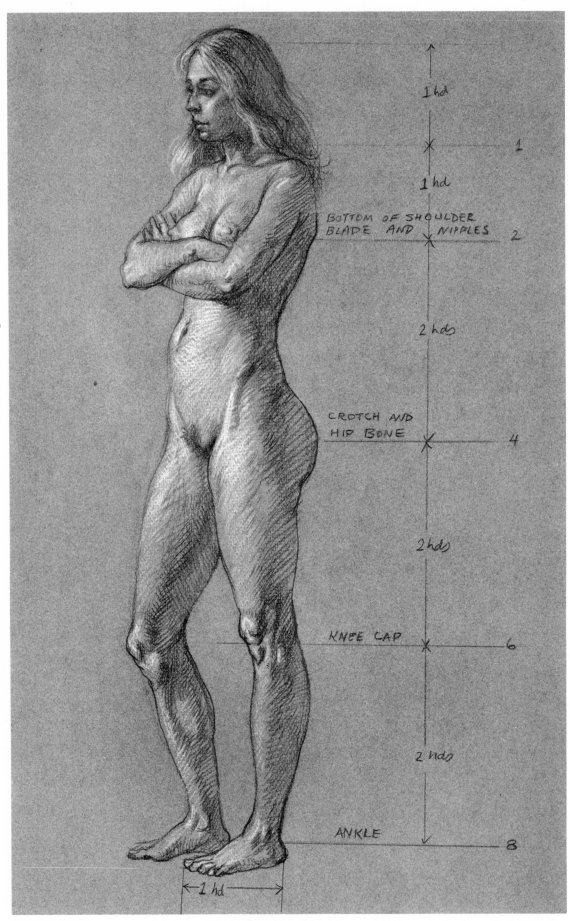

1 hd

1

1 hd

BOTTOM OF SHOULDER
BLADE AND NIPPLES

2

2 hds

CROTCH AND
HIP BONE

4

2 hds

2 hds

KNEE CAP

6

2 hds

ANKLE

8

1 hd

Standing, side view.

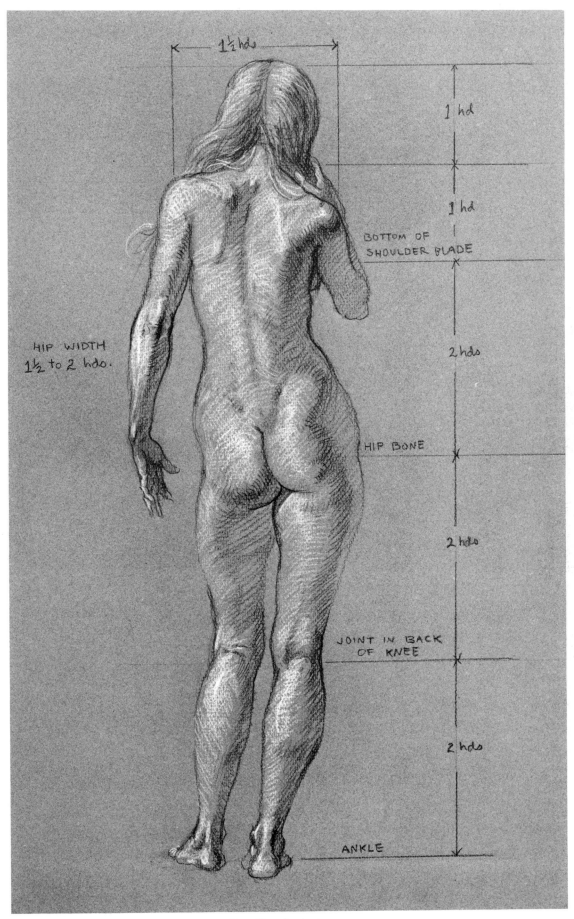

1½ hds

1 hd

1 hd

BOTTOM OF
SHOULDER BLADE

HIP WIDTH
1½ to 2 hds.

2 hds

HIP BONE

2 hds

JOINT IN BACK
OF KNEE

2 hds

ANKLE

Standing, back view.

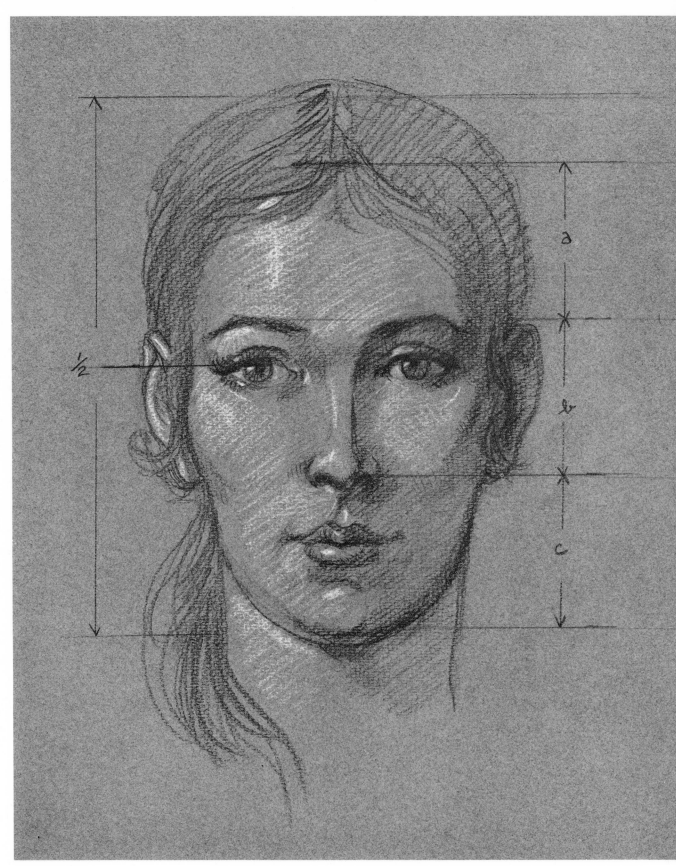

Head, full face. The eyes are halfway between the top of the head and the bottom of the chin. The face can be divided into three equal parts: (a) from the hairline to the eyebrows, (b) from the eyebrows to the bottom of the nose, and (c) from the nose to the bottom of the chin. The ears are in line with the eyebrows and the bottom of the nose. There is a space of one eye between the eyes.

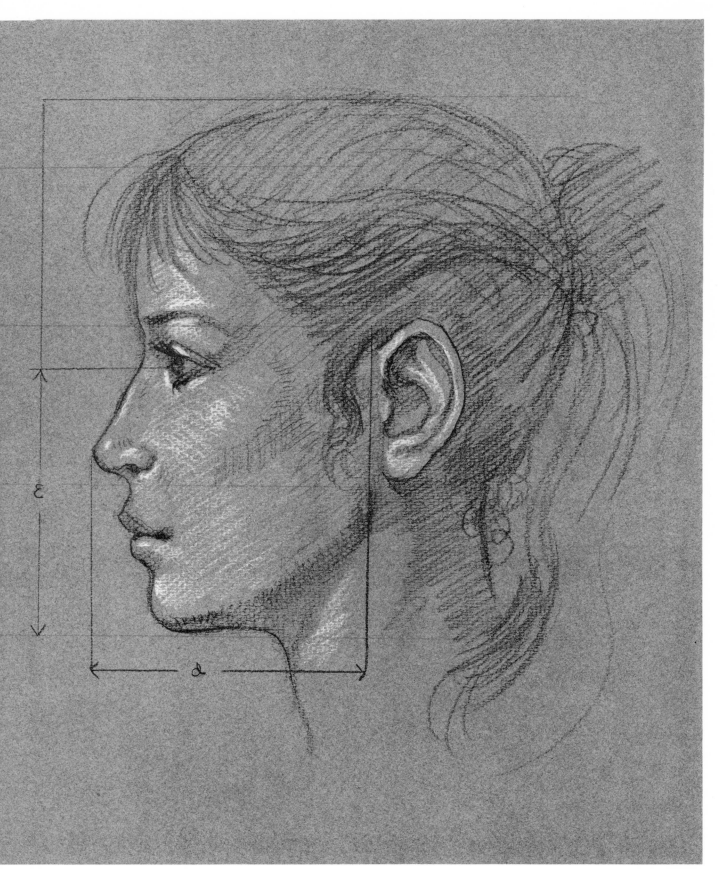

Head, profile. The distance from the tip of the nose to the end of jaw (d) is equal to half the head height (e).

III
FORMS OF THE FIGURE

In discussing the forms of the female figure, we have to see what differences there are between male and female. Females usually carry more fat tissue than males, which covers the skeletal and muscular forms and gives a soft and rounded look. The female is narrow in the shoulders and wide at the hips, just the opposite of the male. The bones of both skeletons are the same, but with the exception of the hips the female is smaller. The facial features are finer and more delicate than the male's. The female neck is more slender and appears longer and doesn't have a distinct Adam's apple. The collarbone is more horizontal, and muscle bulk is not evident in the chest and shoulders. The breasts sit on top of chest muscles and vary in size and shape. The female waist is higher than the male's, and the thighs and buttocks are heavier and smoother. The navel is below the waist and is deepset. The angle of the legs from the hips to the knee is greater in the female and gives her the tendency to be "knock-kneed," while the male tends toward "bowlegged-ness." She has smaller hands and feet, and her body has less hair.

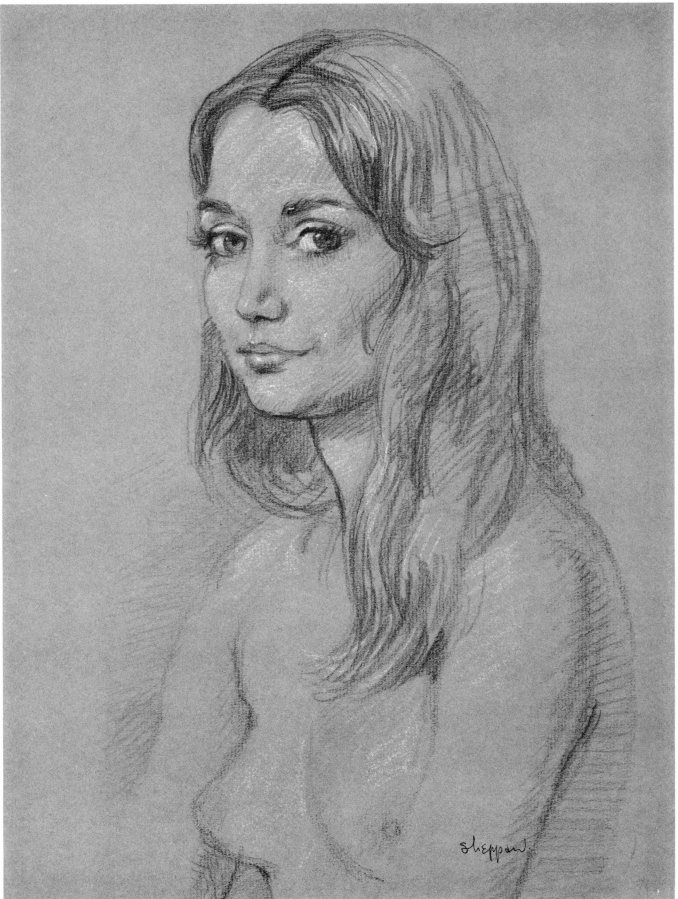

The cheekbones wrap around behind the eye sockets. The line of the jaw is soft and the neck appears long and thin.

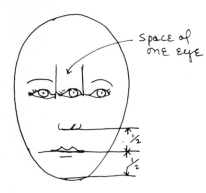

space of
one eye

Right: The forehead is smooth and the
eyelids cover the egg-shape form of the
eyeball. The corners of the mouth end in
dimples. The eye is halfway between the
top of the head and the chin. There is a
space of one eye between the eyes (see
diagram above). The mouth is approxi-
mately halfway between the bottom of
the nose and the chin.

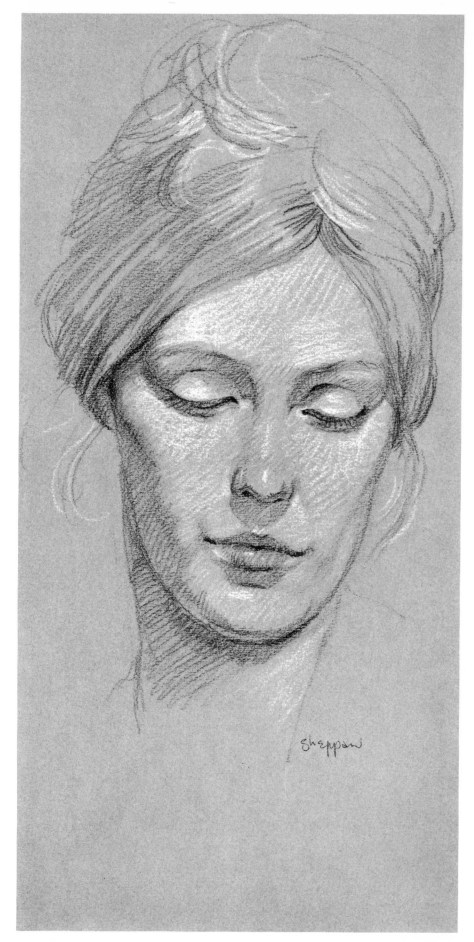

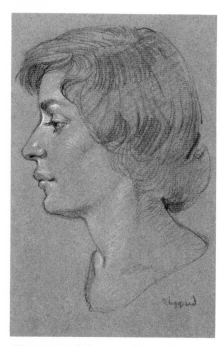

The nose is delicate and fine. The eye
appears large in the head, with long
lashes. The lips are small but full. The
neck is smooth, full but not muscular.

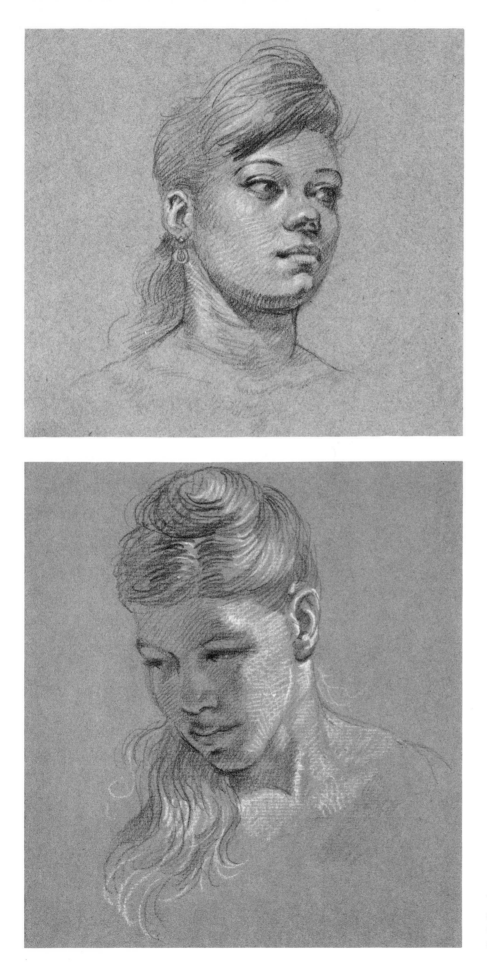

Creases, called "rings of Venus," encircle the neck. The ears, like most of the other female facial features, are smaller than those of men.

The eyebrows and top of ear are in line, as is the bottom of the nose and the bottom of the ear. These lines follow the contour of the skull (see diagram above).

TORSO

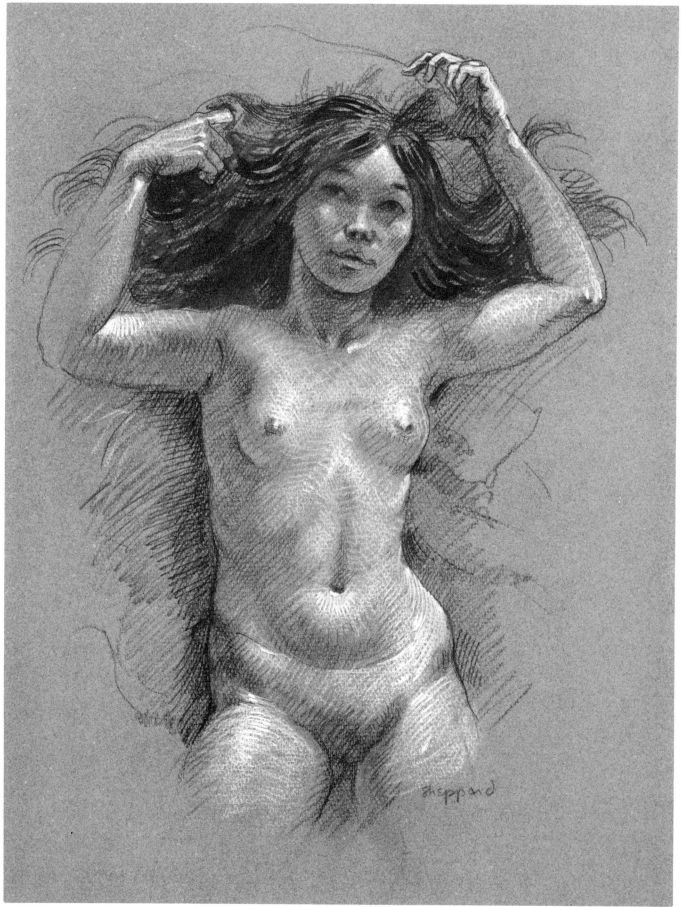

On this teenage girl, the breasts are small and firm. The pelvis is narrow and covered with some fat tissue. The navel is deepset.

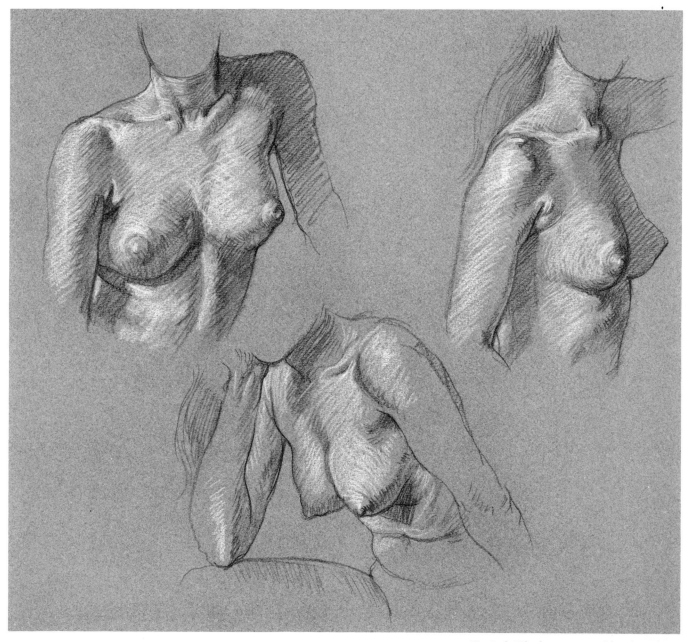

direction of
nipples

comma
shape

Top Left: The breasts are wider than they are high. The nipples point outward from the middle and slightly upward (see diagrams at left). The neck is a cylindrical shape that fits into the torso behind the collarbones.

Center: The breasts attach loosely to the underlying chest muscles. The chest muscles extend out into the arm, forming the front wall of the armpit.

Top Right: Fat extending behind the breast toward the armpit creates a comma shape (see diagram at left). The top outline of the breast is a long, slow curve to the nipple. The bottom outline is a short, sharp curve.

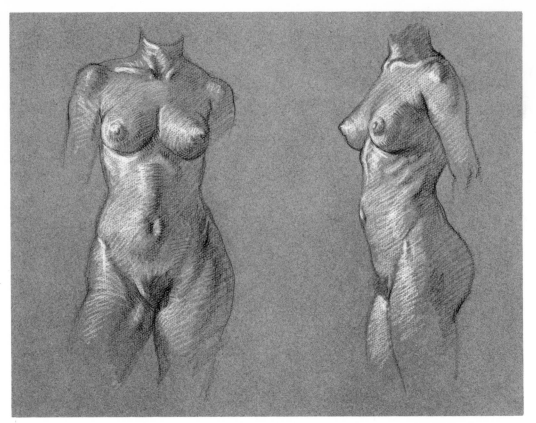

Left: The navel is deepset in the belly. The waist is high and the belly sits into the pelvic basin. The two front points of the pelvis project forward.

Right: The ribs show under the breasts and have a downward slant from back to front.

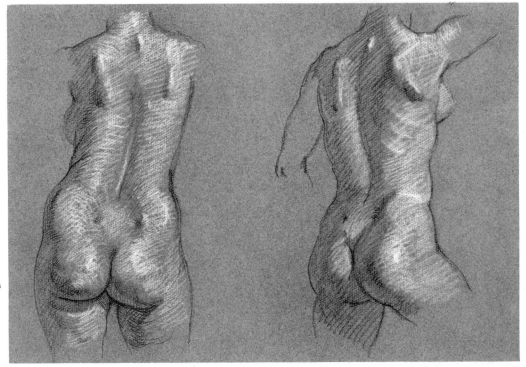

Left: The muscles and fat of the buttocks create a butterfly shape (see diagram at left). At the base of the spine, between the two cheeks, there is a triangular shape formed by two dimples and the crease between the buttocks.

Right: The shoulderbones show on the surface and move with the arm. At the base of the neck the vertebrae are visible.

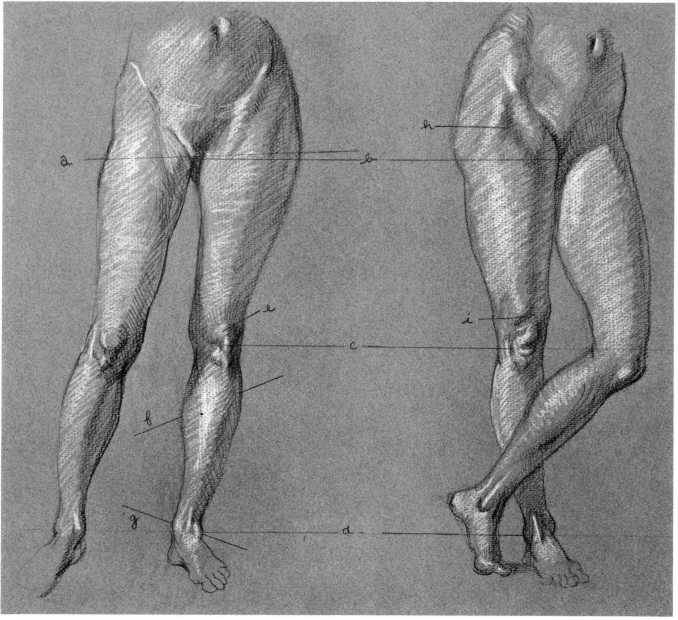

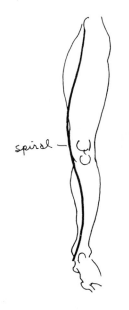

Angle a is the midpoint of the body and goes from one hipbone through the pubic area to the other hipbone. The kneecap is a round shape that rests on line c, which is the midpoint between the hipbone (b) and the ankle (d). Beneath the kneecap is another round, fatty shape (e). The outside of the calf is higher than the inside, making angle f. The inside of the ankle is higher than the outside, forming the opposite angle g. Starting with the hipbone, a muscle runs obliquely across the leg down to the inside of the knee. A spiral line is formed by continuing down the shinbone of the lower part of the leg to the inside of the ankle (see diagram at left).

When the leg is tensed (figure to the right), muscles attached to the pelvis make an upside-down *V* shape (h). The locked knee also causes a depression above the kneecaps (i). The inside of the ankle is farther forward than the outside.

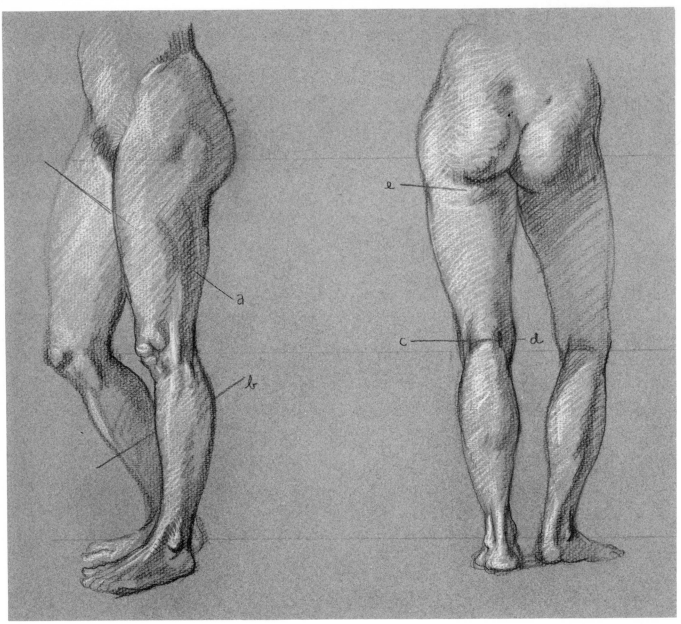

Left: The front of the thigh is higher than the back (angle a). The back of the calf is higher than the front (angle b). The locked leg forms the letter *S* (see diagram at left).

Right: The muscles and the crease behind the knee (c) form the letter *H*. The inside of the knee has a definite angle (d). There is an extra fold of fatty tissue below the large swell of the buttocks (e).

Curve

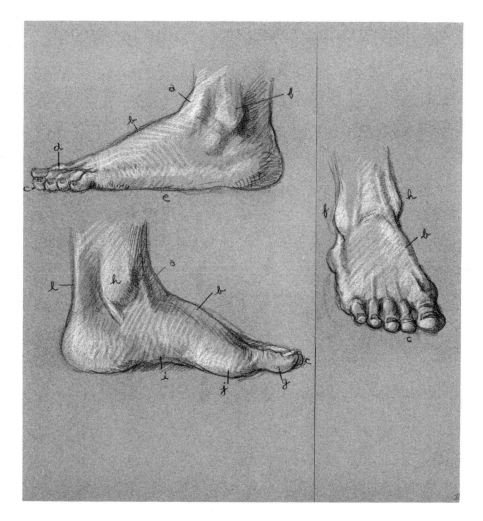

Far Left, Top: The outside of the foot. Tendons come down into the foot from the leg, forming a flat bridge on the front of the ankle (a). There is an arch on the top of the foot on the big toe side (b). The toe next to the big toe (c) is the longest. The smaller toes have a "stepdown" shape (d). The outside of the foot is flat (e) and is covered with a deep pad. The outside anklebone (f) is in the center of the ankle.

Far Left, Bottom: The inside of the foot. The big toe (g) has one joint fewer than the others. The inside ankle (h) is higher than the outside and farther forward. The inside of the foot has an arch (i) on the underside. The ball of the big toe (j) is round and protrudes. The heel has one large tendon (l) attached to it.

Left: Front view of the foot. The inside anklebone (h) is higher than the outside (f), and a large tendon makes a ramp down the front of the foot to the big toe (b). The ends of the toes have rounded fatty pads (c).

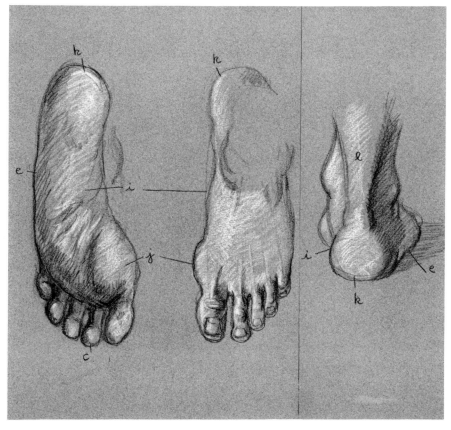

Far Left: Bottom of the foot. Wrinkles form around the arch (i) on the instep. The ball of the foot (j) has a large pad on it. Pads cover the outside of the foot (e). The heel (k) is also well padded and is located on the outside of the foot.

Center: Top view of the foot.

Left: Back view of the foot. A large tendon (l) attaches to the heel (k). The instep arch (i) and the padded outside contour of the foot (e) are also indicated.

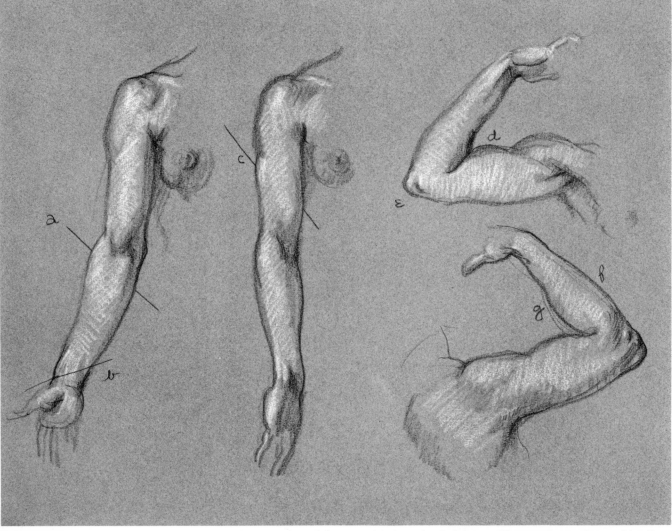

Left: Front view of the arm with the palm facing out. The muscles on the outside of the arm attach higher than the elbow, making an angle (a). The inside of the elbow protrudes. The thumb side of the wrist (b) makes an opposite angle.

Center: Front view of the arm with the palm turned out. The silhouette of the outside of the arm is higher than the inside (c).

Top Right: Front view of the arm, bent. The bones of the elbow (e) protrude. The muscle on top of the upper arm (d) bulges.

Bottom Right: Back view of the arm, bent. The top of the forearm (g) is made up of a curve and a straight line. The underside of the forearm is one long curve (f).

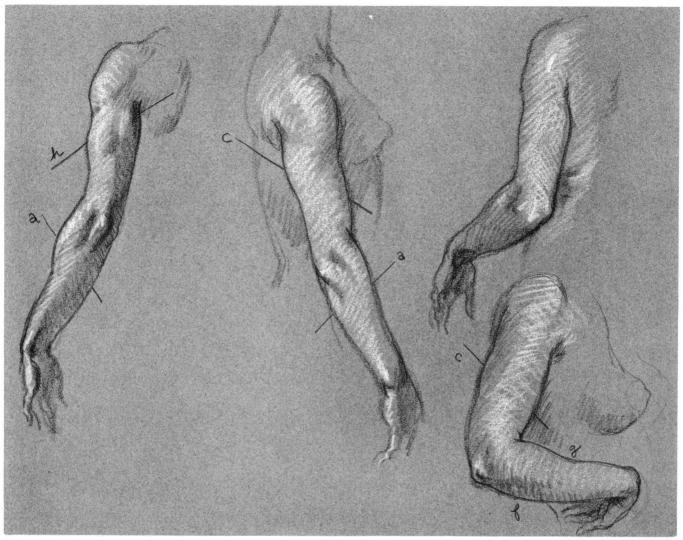

Left: Back view of the arm shows the fullness of the inside of the upper arm higher than the outside (h), and the angle (a) formed by the high muscle of the lower arm.

Center: Side view of the arm.

Top Right: Back view of the bent arm reveals the bones of the elbow in a triangular shape.

Bottom Right: Side view of the arm, bent.

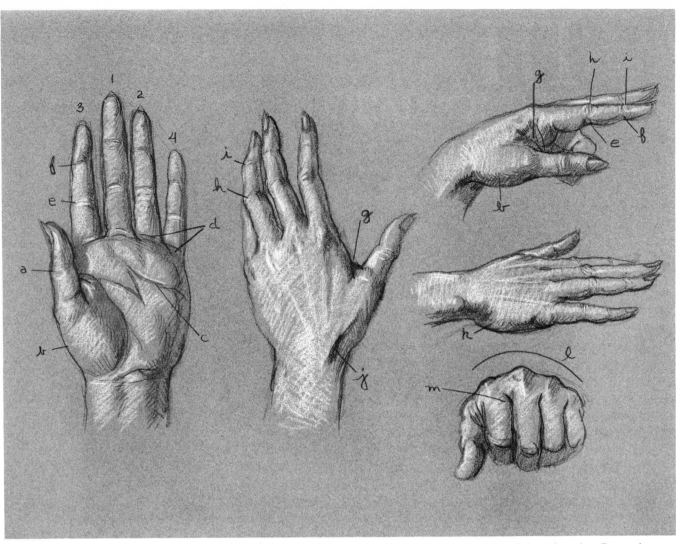

Left: Palm view of the hand. The thumb (a) has only two joints, the other fingers have three. The ball of the thumb (b) sits separately from the rest of the hand. Folds in the palm (c) create the letter *M*. The fingers are numbered here in order of their length. Folds (d) are created on palm where fingers bend: the two middle fingers have two folds; the little finger and the index fingers have one fold. Joint e has two folds and joint f has one fold.

Center: Back of the hand. Knuckle i has smooth creases and knuckle h has fleshy folds of skin. The muscle that pulls the thumb across the hand (g) is attached on the palm side. There is a small triangular depression, caused by tendons to the thumb, called the "snuff box."

Top Right: Thumb side of the hand.

Middle Right: Little finger side of the hand. Muscles form long pad on little finger side (k).

Bottom Right: Fist. An arch is formed (l) when hand is made into a fist, the middle finger knuckle being the highest point. The creases from the middle finger point outward (m).

IV
DRAWING PROCEDURE

It is important to remember that when you are drawing a figure you are drawing something alive, not a still life. Anatomy and proportion, no matter how important and correct, will not make a figure drawing live. Overrendering can freeze the figure and make it look like a statue, dead. Some of the greatest examples of living drawings are those of Tintoretto and Rubens.

Rubens understood the soft edge that put his figures in atmosphere and the distribution of weight that made his figures move. With intentional sketchiness he suggested motion. His knowledge of live muscular form made his figures breathe.

I do not believe it is wise to draw slowly or have a model pose for long periods. It is important to train a visual memory and be able to re-create the figure, make it do what you want and not be a slave to the model. A camera can imitate what is in front of you better than you can, so why bother.

Finding the "key" line, or rhythm, is the first step in drawing the figure. Whether it is an *S* curve, *C* curve, or other line, each position has one line that is important. Most often it is the longest continuous line in the body, a kind of sweep. In a standing position, it could be a continuous line drawn from the top of the head all the way down to the toes.

The "attitude" is how the figure is standing and what it is doing. Any posed figure is naturally balanced; a figure in action is often off-balance. The way the weight is distributed is part of the attitude. When establishing the attitude, it is important to check angles and extend plumb lines from the model and see if her angles correspond to those in your drawing.

After the first key line, or sweep, is found and the attitude constructed, the next step is to suggest the outlines of the figure. It is important to indicate which lines overlap each other. By making lines darker or lighter, we can make them project or recede.

The next step is to indicate the shadow accent, the broken line between light and shade. This line can be hard and sharp or soft and diffused. The shadow accent seems to be the most difficult part to train the eye to see: it is the inside form of the outline.

The cast shadows should be drawn next. They are darker and sharper next to the part of the body that is casting them. They relate the different sections in space and to each other.

The shadow can now be filled in between the shadow accent and the outline. Shadows seem to be transparent and can best be rendered by line or cross-hatching. It's a good policy not to get them too dark. Save the darks for the shadow accent and beginning of the cast shadow. Shadow lines can also follow the contour of the form, helping to explain it.

The reflection in the shadow should never be as light as the halftone. On toned paper, the paper can be used for the halftone, and white chalk, Conté, or paint can be used for the highlights. Using the paper tone as much as possible gives the drawing more life. Very often on white paper the halftone and highlights are treated as one. Sometimes a halftone is rendered around a highlight or the highlight is erased from a halftone, but this requires more time and work.

Step 1. Find the "key" line, or rhythm, of the figure. It is often the longest unbroken line in the body.

Step 2. Now we find out how the weight is distributed and what the figure is doing. This is called the "attitude." Line a is the key line. Leg b is the supporting leg that balances the figure and keeps it from falling over. Lines c are contour lines showing the volume of the figure, and line d shows the angle of the breast and shoulders. Line e is the angle of the hips.

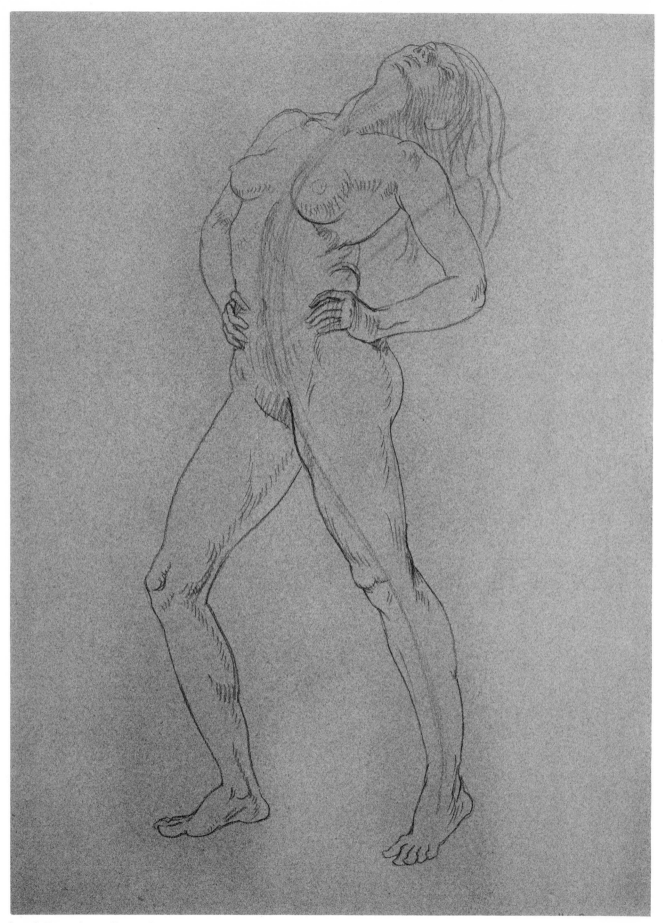

Step 3. Draw the outline and indicate the shadow accent. It is important to see where the shadow is hard and where it's soft.

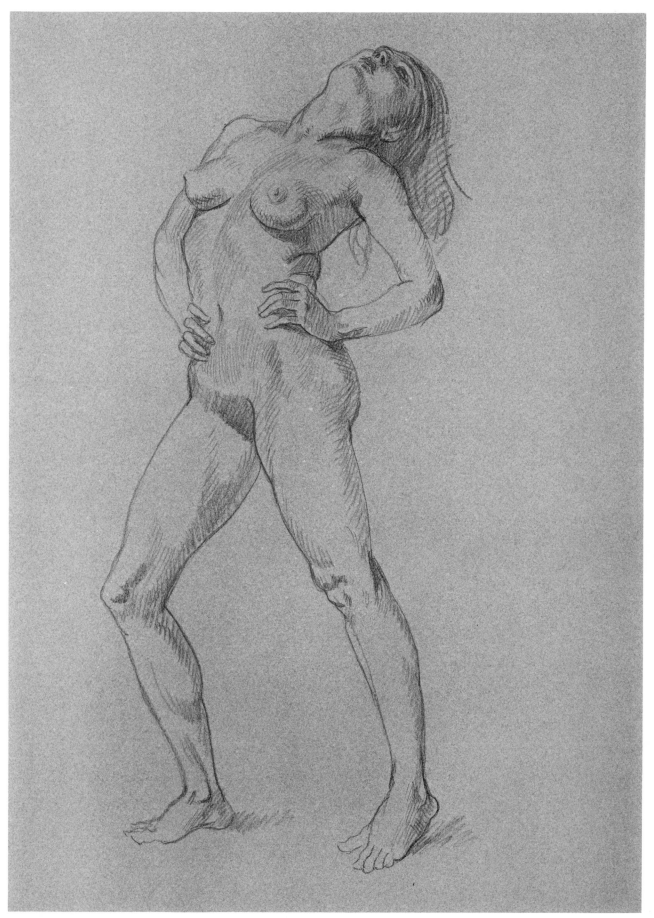

Step 4. Block in the shadow and render the variations in the halftone.

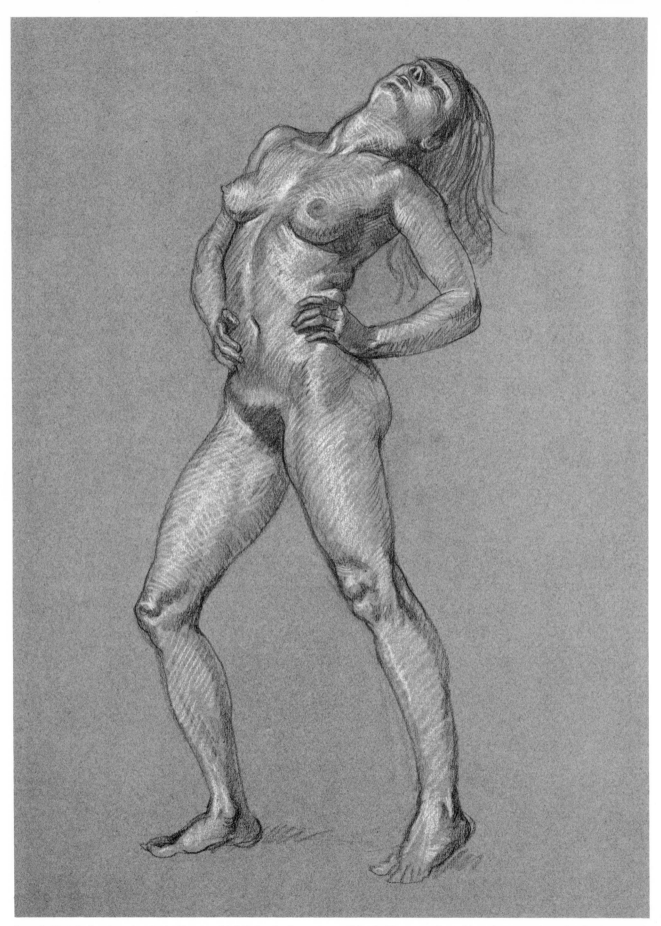

Step 5. Finish the drawing by indicating highlights in the center of the halftone and working them out into the form.

V
THE STANDING FIGURE

The standing figure is seen with less foreshortening than most other poses, enabling the artist to use the standard eight-heads measurement easily.

There are three basic ways a figure can stand: with all the weight on one leg and balanced with the other, with the weight evenly distributed on both legs, or with the weight on one leg and the other raised.

When the weight is on one leg, it throws the hip on that side higher than the other. The shoulders then usually balance the figure by making an opposite angle, giving the figure the classic *contrapposto* stance. When the weight is equal on both legs, the shoulders are usually straight across.

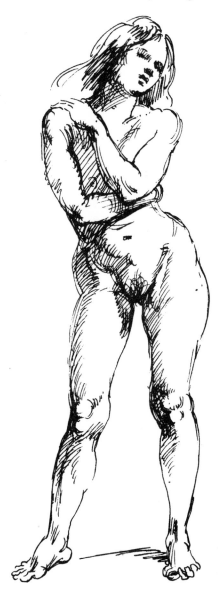

The kneecap is round, like a silver dollar, and beneath it is a similar fatty shape. The outside of the calf makes a smoother but higher silhouette than the inside, creating an angle from the outside down to the inside. The ankle has an opposite angle (see diagram below).

FRONT VIEW

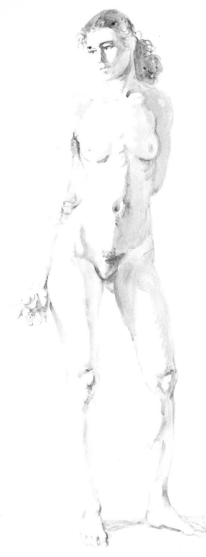

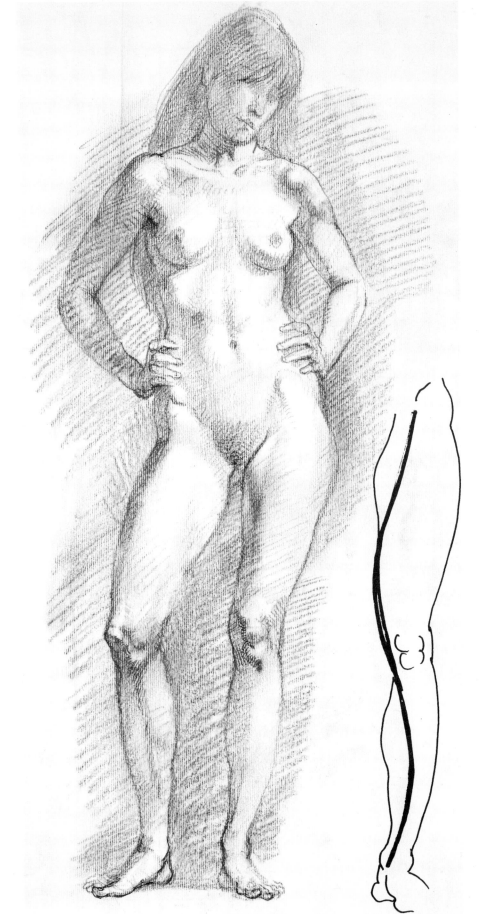

Above: The outside of the leg starts from the pelvic bone, which is higher than the midpoint of the body. This gives the upper part of the leg the appearance of being longer than the lower part. The breasts follow the same angle as the shoulders.

Right: On the left thigh, a shadow from a muscle descends down to the inside of the knee and makes a continuous spiral down the edge of the shinbone to the inside of the ankle (see diagram, far right). The inside of the ankle is always higher than the outside.

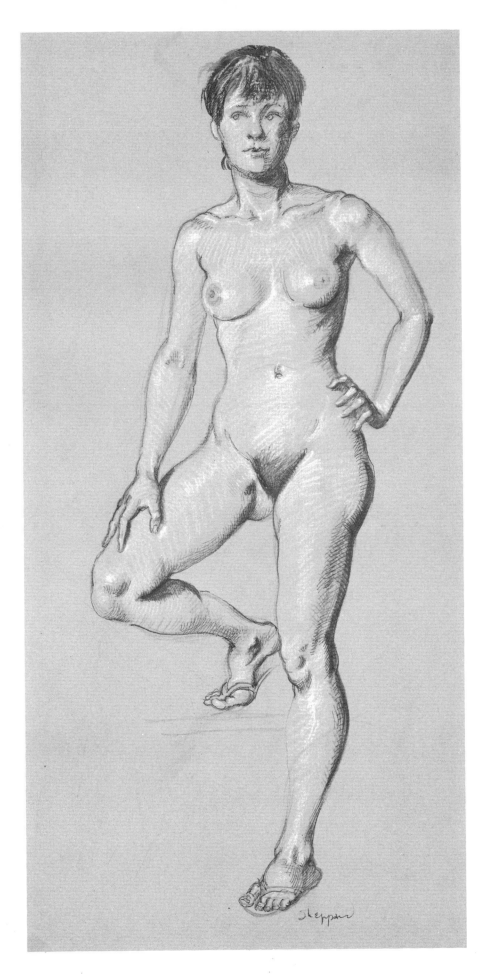

The left leg is locked, pushing the knee back. This puts the leg in an *S* shape (see diagram below). The outside of the right forearm rises above the elbow, which is prominent on the inside of the arm.

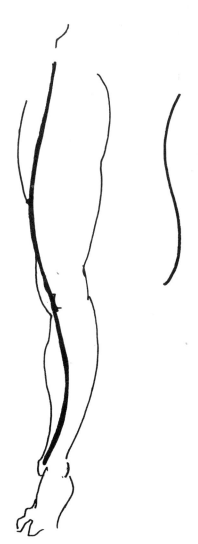

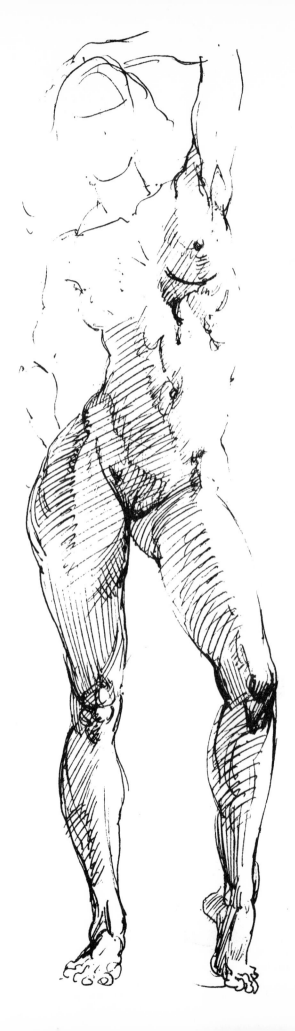

opposite angles

weight being carried on this leg

The weight of the torso is on the right leg, which forces the right hip higher than the left. The left leg is used to balance the figure. The shoulders slant in the opposite direction from the hips. This attitude is called *contrapposto* (see diagram above).

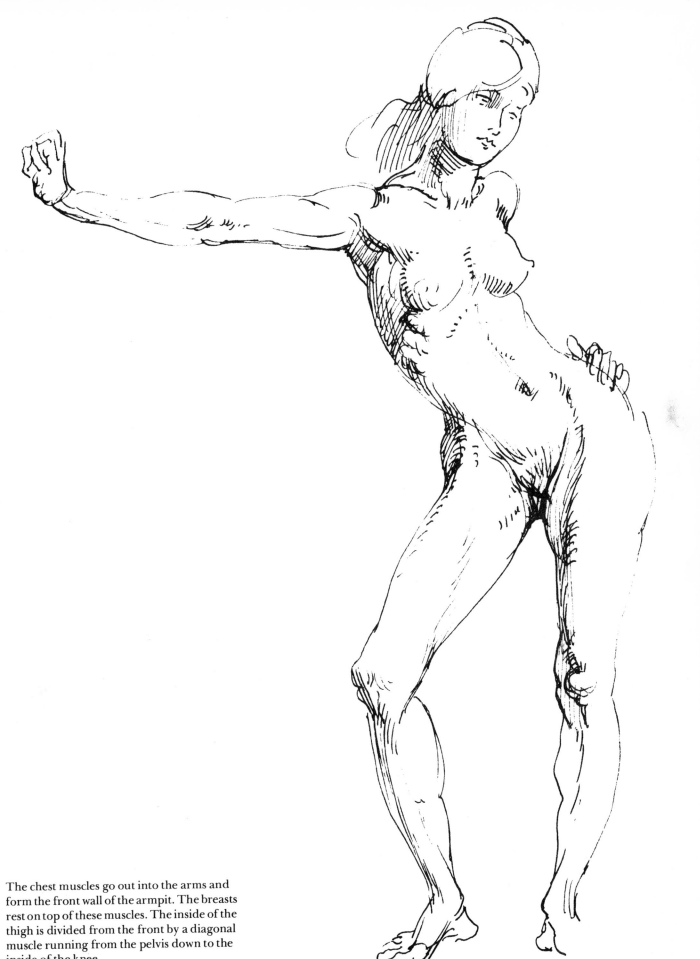

The chest muscles go out into the arms and form the front wall of the armpit. The breasts rest on top of these muscles. The inside of the thigh is divided from the front by a diagonal muscle running from the pelvis down to the inside of the knee.

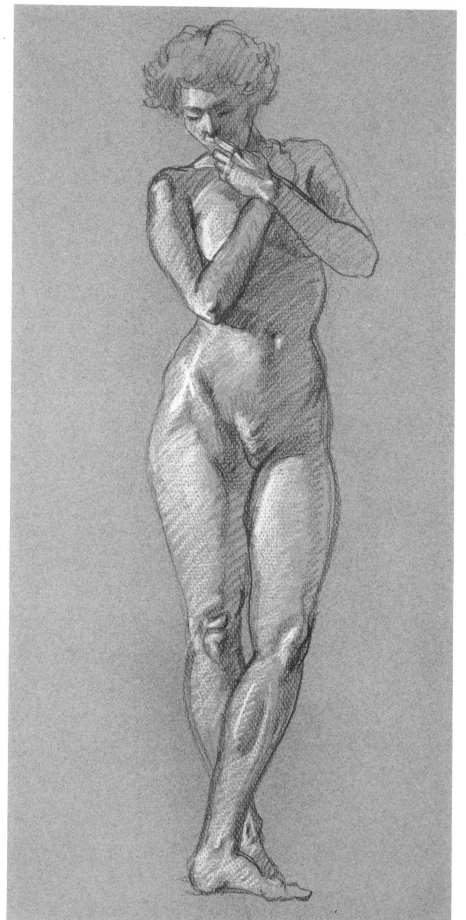

Above: The neck sits into the center of the torso, with the shoulder muscles in back of it and the collarbones in front. The second rib attaching to the breastbone shows as a horizontal line across the chest. Fat over the pelvic ridge makes the waist higher on women than on men.

Right: The figure stands in the contrapposto position. The navel sits deep into the belly. The forearm has two bones, the one on the thumb side of the wrist is longer than the one on the little finger side.

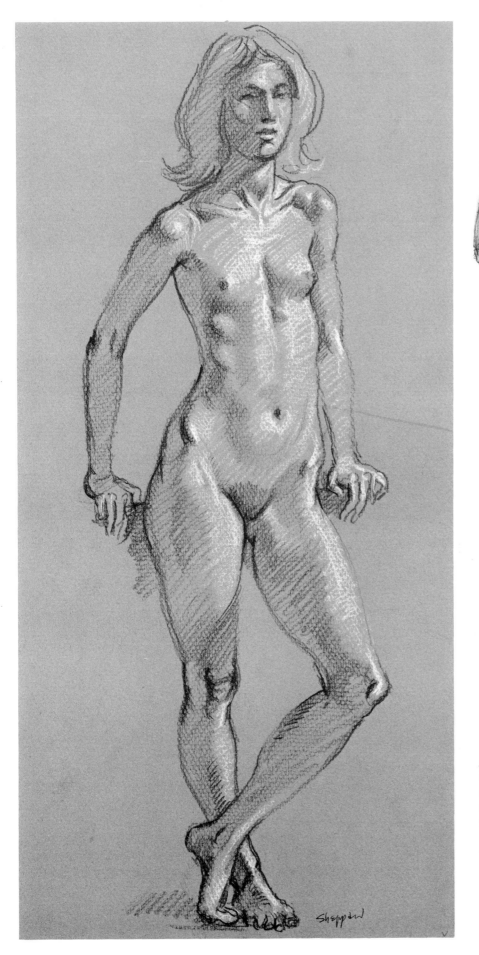

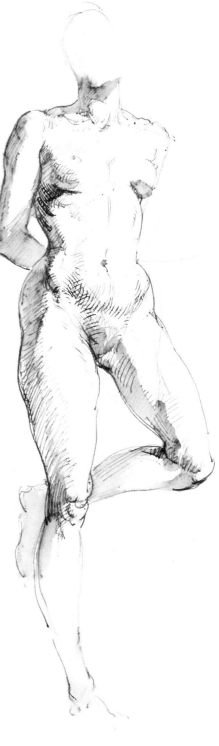

Above: The ribs can be seen under the breasts as they attach in the back and come downward toward the front. The front edges of the pelvis on each side support the belly.

Left: The collarbones start at the base of the neck and angle back and out to the tips of the shoulders. There are muscles that start behind each ear and angle down to the middle of the front of the neck and attach between the collarbones, forming a *V* shape.

BACK VIEW

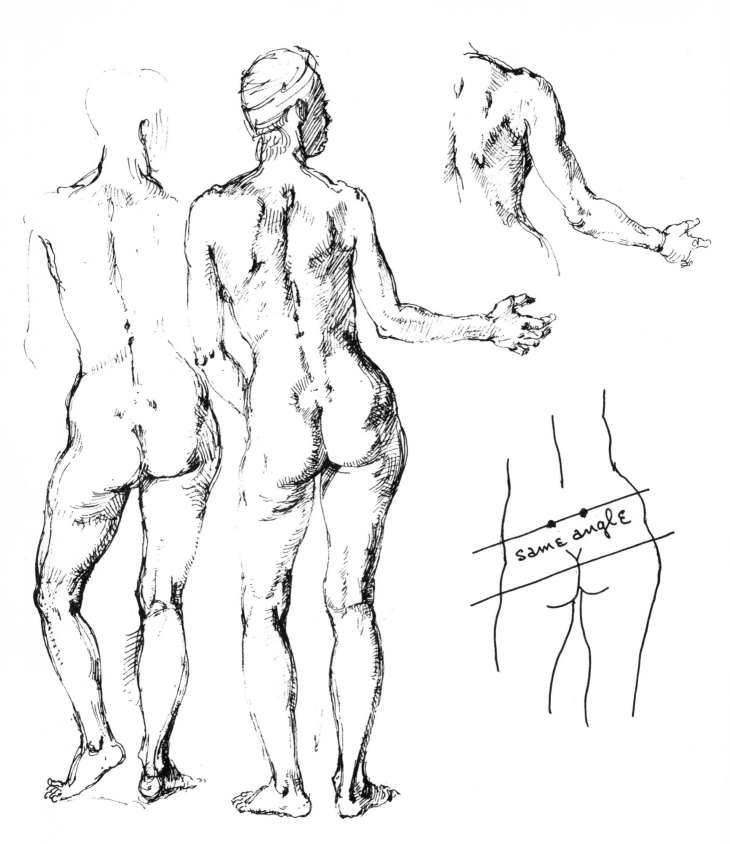

same angle

Vertebrae are visible, expecially those at the back of the neck. The buttocks form a butterfly shape. The two dimples formed by the end of the pelvic crest are in line with the angle of the hips (see diagram at right).

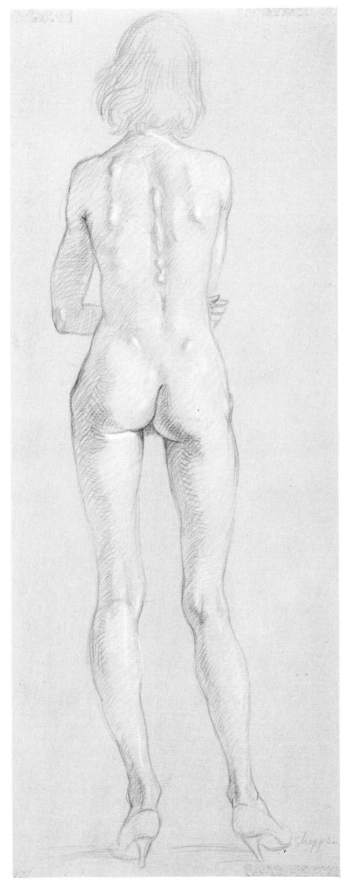

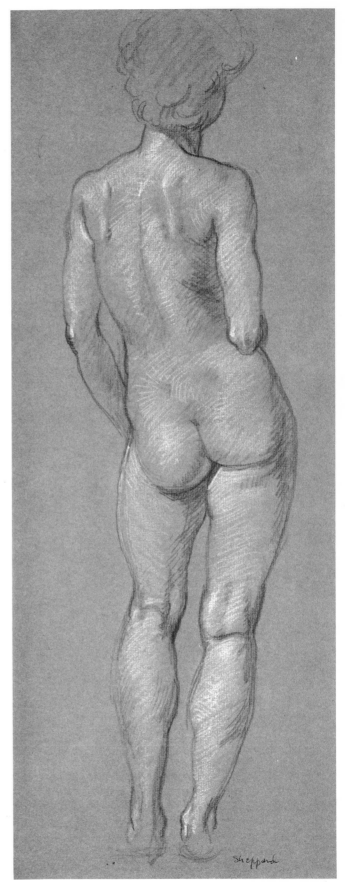

On a thin model, the two ends of the pelvic crest protrude instead of forming dimples. The muscles on the back of the knee along with the crease form the letter *H*.

Small fat deposits form where the arms join the torso. On the back of the right arm the muscles form an angle, with the inside higher than the outside.

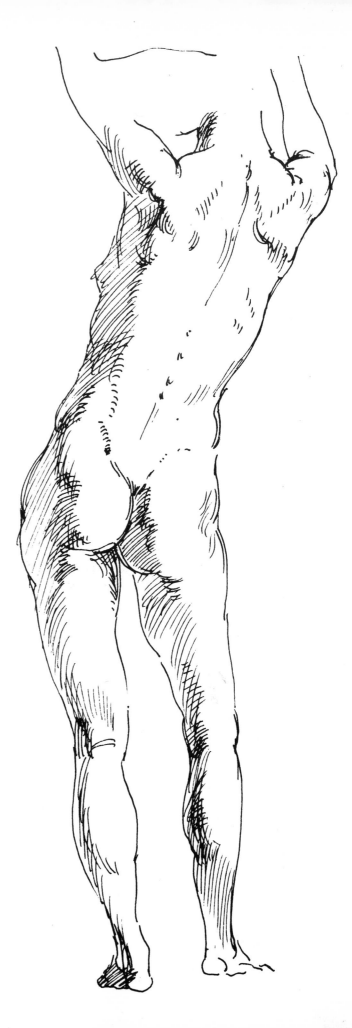

Above: The ribs angle down from under the shoulderblades toward the front of the body. Beneath the buttocks there are fat deposits. The bone on the little finger side of the wrist is more prominent than the one on the thumb side.

Right: When the arms are raised, the shoulderblades follow. The left leg angles down under the body to give support, causing the left hip to protrude. The inside of the ankle is higher than the outside.

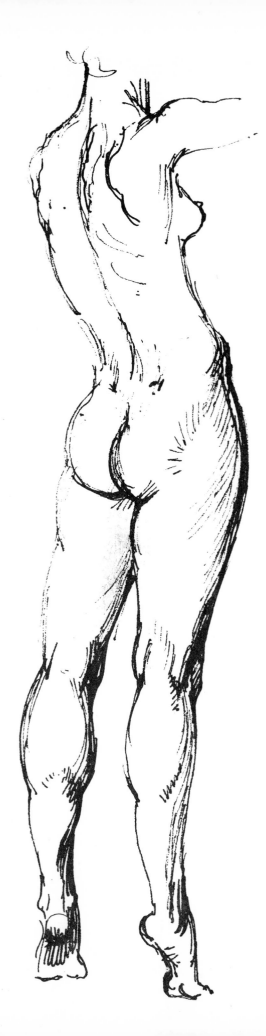

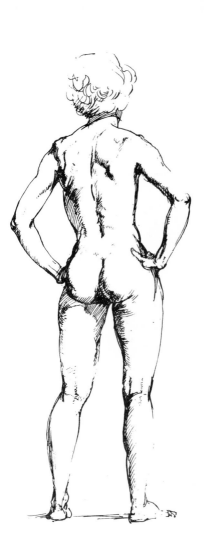

Above: The shoulder angle is straight and the weight is evenly distributed on both legs. Fat deposits on the outside of the hips are normal. The tips of the shoulderblades are seen on the tops of the shoulders. Shoulder muscles rise toward the neck and attach to the back of the head.

Left: The calf muscles flex and become hard when the model stands on her toes. The buttocks also tighten.

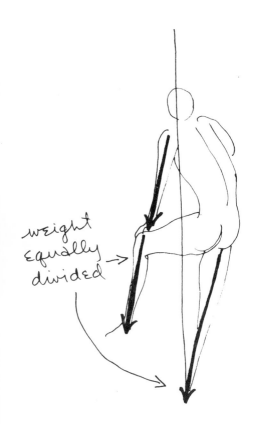

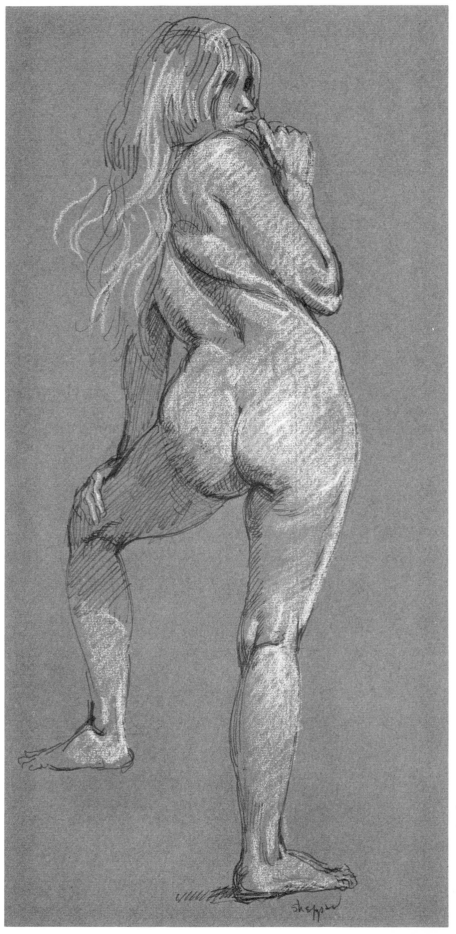

weight equally divided →

Here, the figure twists and leans forward with her left elbow locked for support. The weight is equally distributed between the right leg, which angles back under the center of the torso, and the combination of the left arm and the left calf (see diagram above). Deep folds form on the back, accenting the rhythm of the figure.

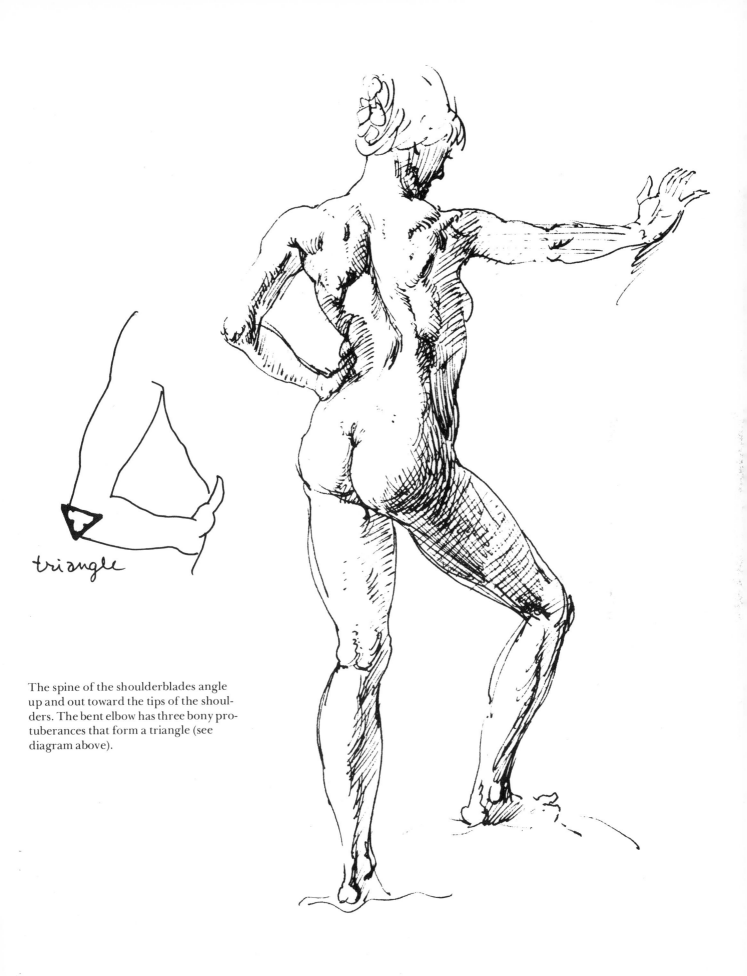

triangle

The spine of the shoulderblades angle
up and out toward the tips of the shoul-
ders. The bent elbow has three bony pro-
tuberances that form a triangle (see
diagram above).

SIDE VIEW

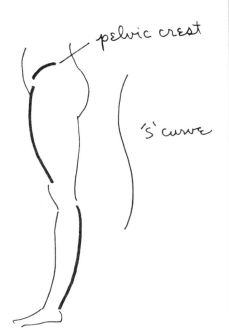

pelvic crest

'S' curve

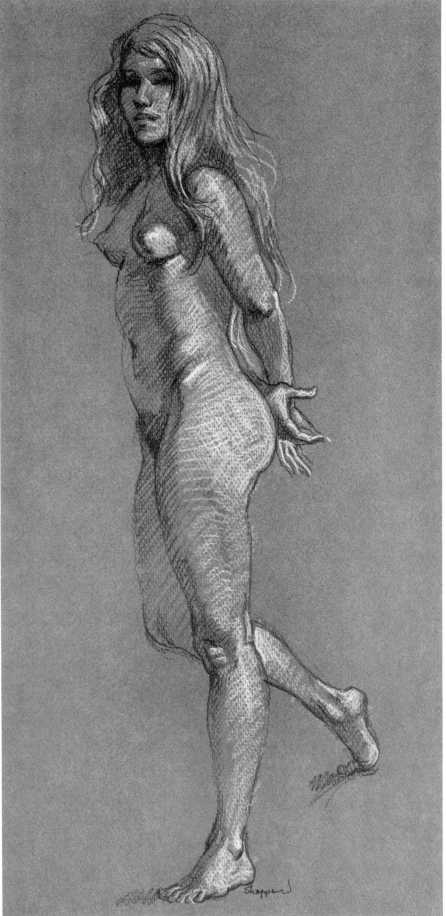

The left knee is locked in order to hold
the weight of the body. In this position
the leg forms a graceful S curve (see
diagram above). The upper part of the
leg starts with the pelvic crest and in-
cludes the buttocks.

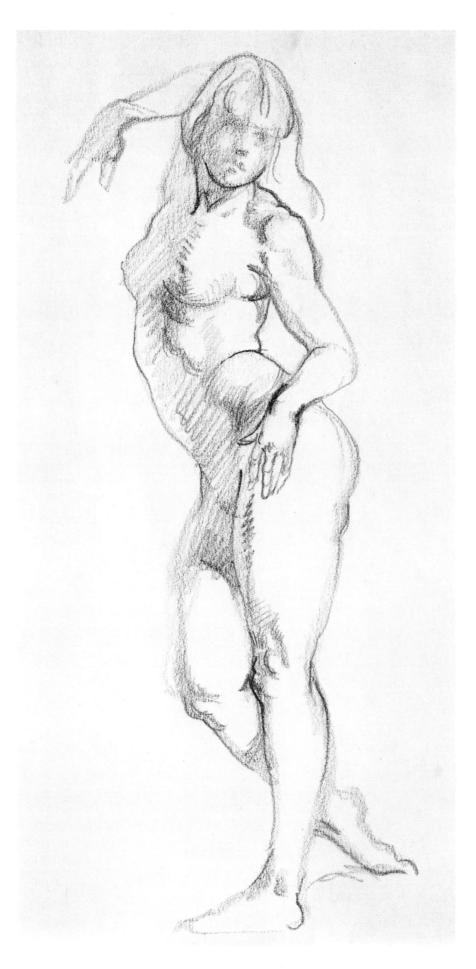

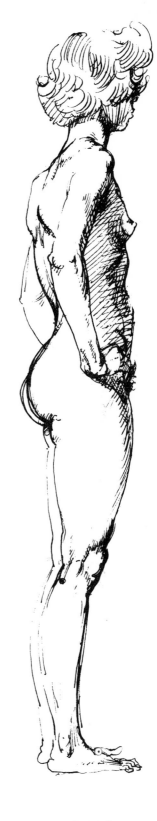

Above: The shoulderblades are prominent and even. The shape of the ribcage projects beneath the breast.

Left: In this twisted pose, the weight is distributed between the left leg and the right arm. Fat deposits are evident under the arms to the breasts and under the buttocks.

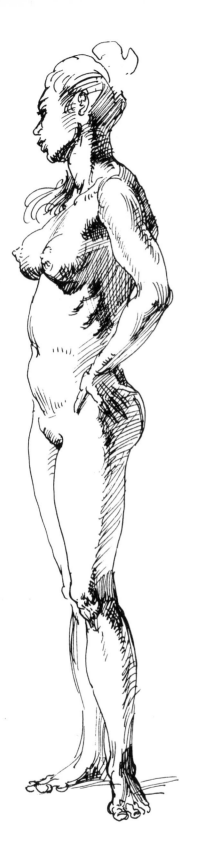

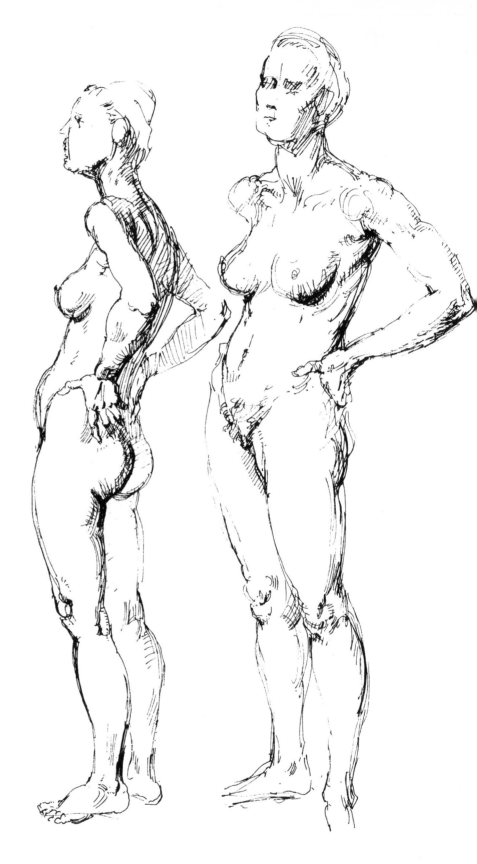

The breasts sit on top of the chest muscles. The chest muscles insert into the arm and form the front wall of the armpit. A muscle attaches behind the ear and crosses obliquely down the neck and inserts in front, between the collarbones.

In these two views the backbone is arched, pushing the shoulders forward. The belly protrudes in front and is held by the pelvic crest. The knees are locked and the weight is evenly distributed. The shoulders and hips are straight across.

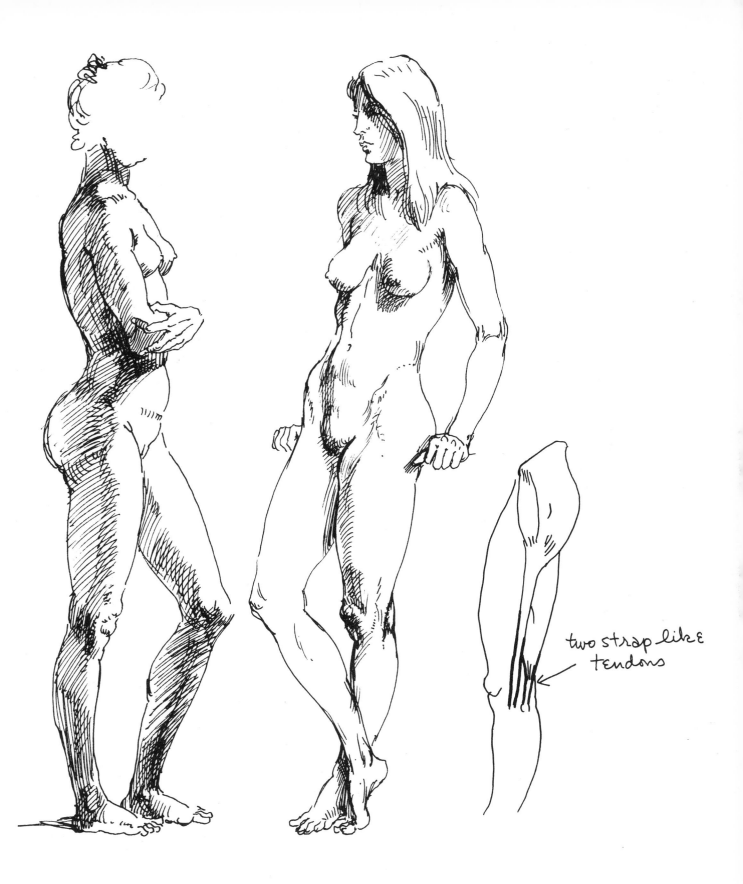

two strap like tendons

The arched back forms an *S* curve. The locked right leg is in a reverse *S* curve. The left leg is being used for balance only.

Tendons from the thigh form two straps on the outside of the knee. The pelvic line is well marked on a thin model (see diagram at right).

opposite
angles

Right: The wrist forms a flat plane between the bones of the forearm and the hand. The silhouettes of the upper arm and forearm form opposite angles (see diagram above).

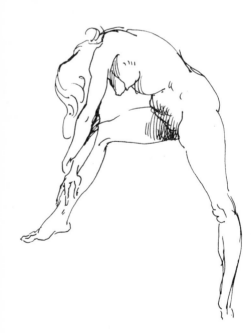

Above: The arm begins with the shoulderblade. The outside of the forearm connects above the elbow. The left leg angles in under the torso to help support the weight of the body.

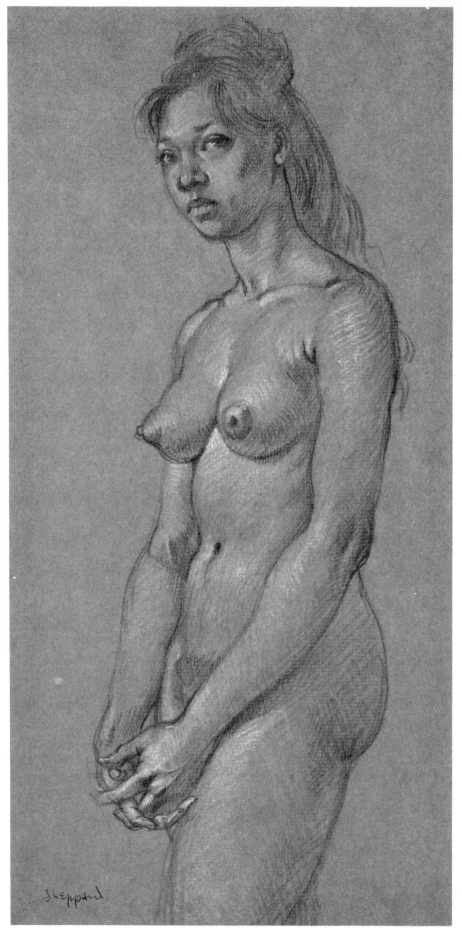

Sheppard

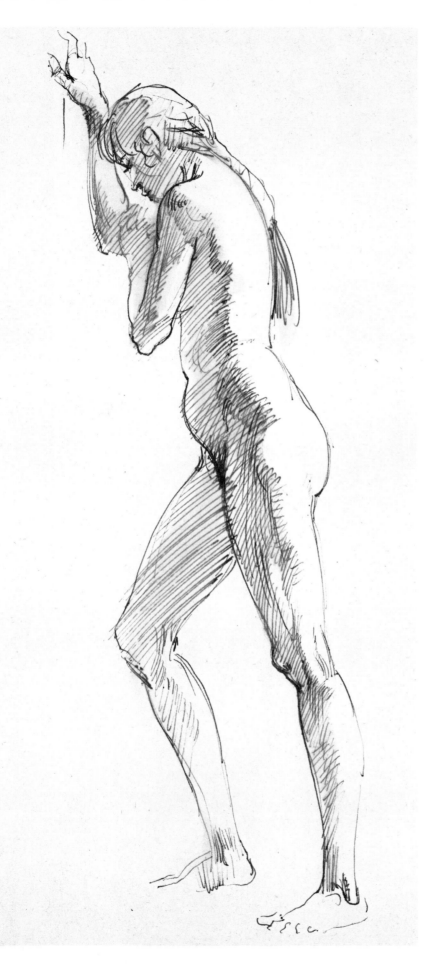

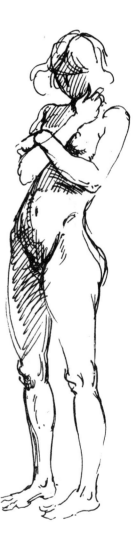

Above: The inside anklebone is toward the front of the foot, and the outside bone is in the center of the ankle. The inside of the calf is more prominent than the outside. The head leans forward to balance the curved backbone.

Left: The model's weight is pushed forward against a wall. Without the wall the figure would look as if it were falling down. The left leg is locked, forming the *S* curve.

VI
THE SEATED FIGURE

In the seated position, the weight is transferred from the legs and feet to the buttocks and thighs. Sometimes the weight is also distributed to the arms and head.

The legs as well as the arms are more likely to be foreshortened, creating more difficulty in drawing.

Most seated figures can be measured as six heads tall: four for the torso and head, and two for the lower part of the leg. The upper part of the leg is usually parallel to the floor.

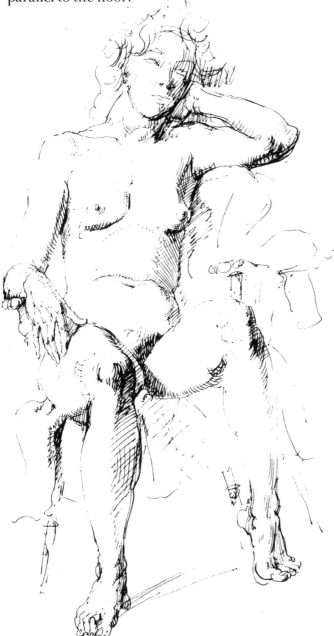

It's important to define the knee in order to make it project and the thigh recede. When the model sits, folds form across the stomach.

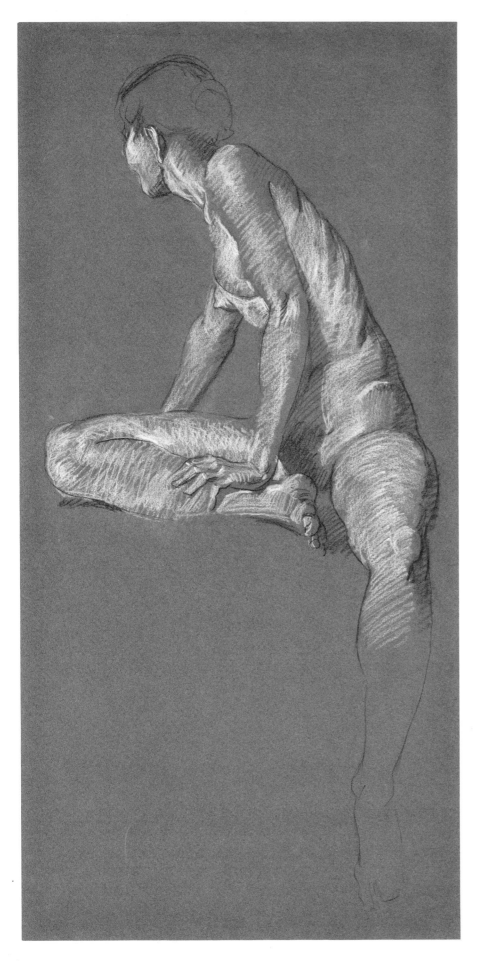

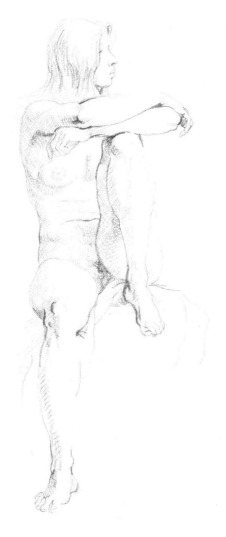

Above: The weight put on the right thigh flattens it. The elbow is accented in order to make it come forward.

Left: The right leg is bent back on itself, forcing the muscles to bulge where it creases. The right shoulder isn't seen, but the shoulder angle is indicated by the angle of the breast.

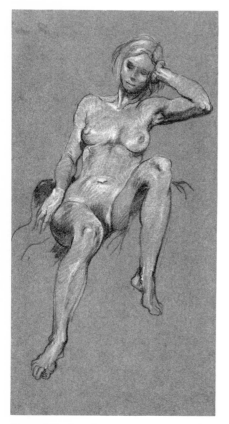

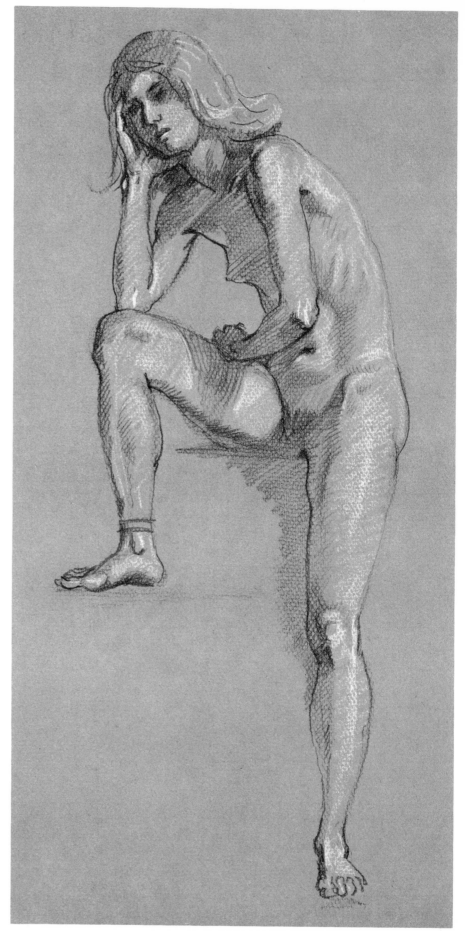

Above: Overlapping contours create the foreshortening of the torso. The closest form overlaps the form behind it, and that form in turn overlaps the next. Tendons from muscles in the arm enter into the torso between the front and back of the armpit walls.

Right: In this pose the model half sits, half stands. The three points of the elbow make a triangular shape. The pelvis protrudes, and the downward angle of the ribs shows.

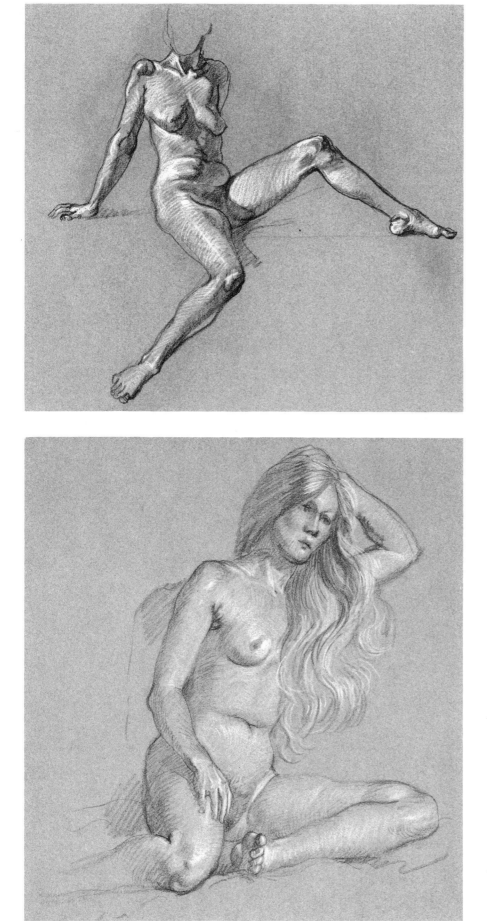

Locked arms support the leaning torso and push the shoulders high and forward. The collarbones go behind the shoulders. Folds on the belly are caused by the raised leg.

The softness of the thighs and belly is typically female. The bones are less evident than in the male, except in the knees, wrists, and elbows.

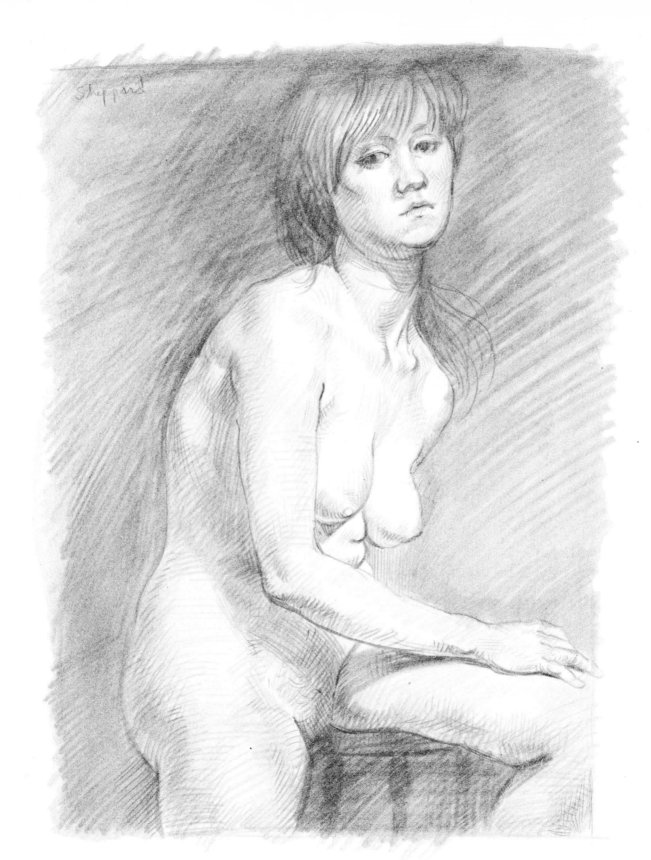

Fat folds appear under the armpit, both in front and back. The stomach has several folds where it bends in on itself.

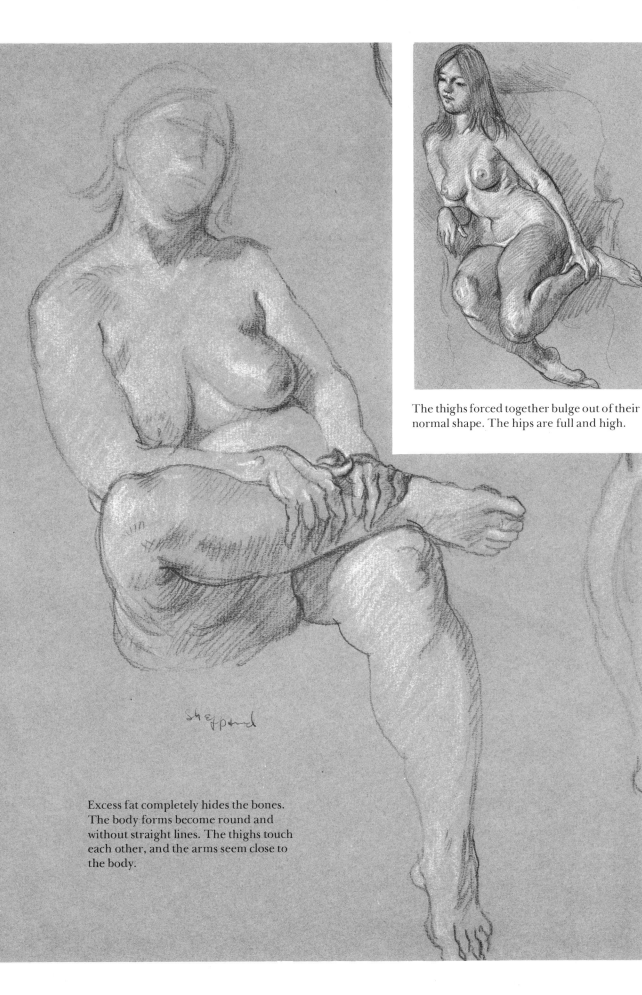

The thighs forced together bulge out of their normal shape. The hips are full and high.

Excess fat completely hides the bones. The body forms become round and without straight lines. The thighs touch each other, and the arms seem close to the body.

BACK VIEW

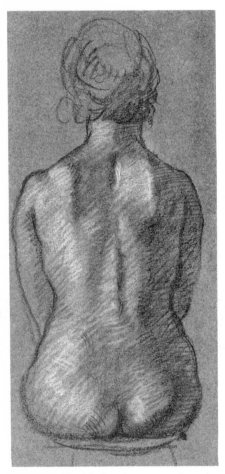

The shoulderblades show even though the model is fleshy. The buttocks flatten out from the weight of the body.

The female back has more fat and is smoother than the male's. The outline of the shoulders extends up toward the back of the head. There are two dimples at the base of the backbone caused by the spines of the pelvis.

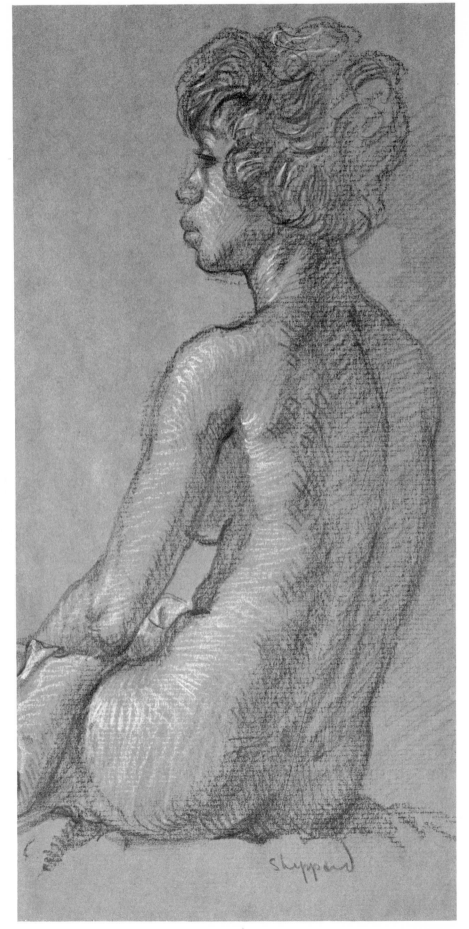

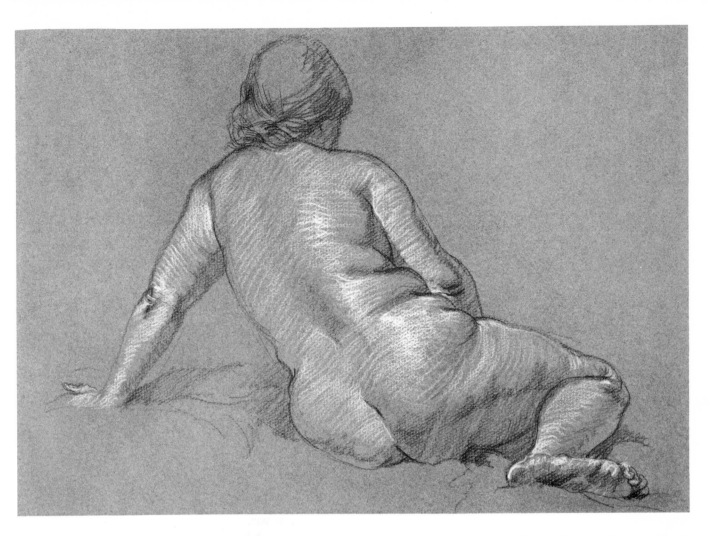

Above: Dimples form on the buttocks and thighs. Bones disappear except at the elbow. Here the torso weight is supported by the locked left arm.

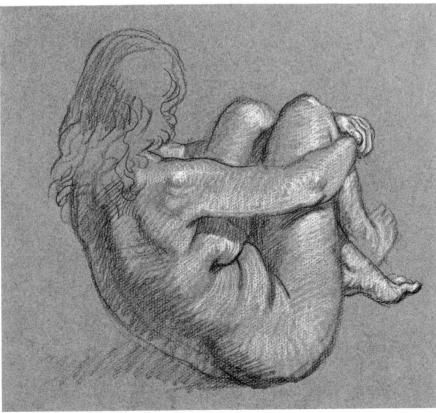

Left: Breast and belly overlap as torso and legs squeeze together. Angle of shoulderblade follows direction of arm.

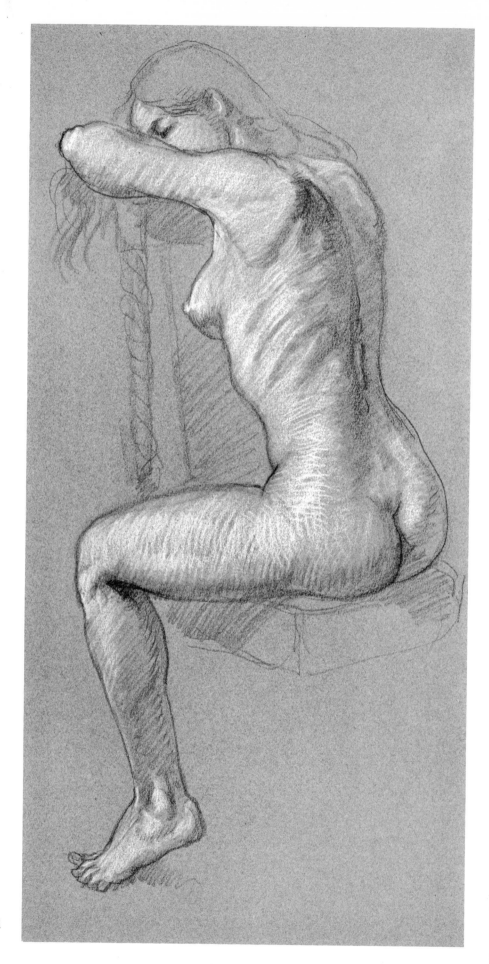

Muscles attached to the shoulderblade
insert into the arm. Vertebrae on the
backbone show down the center of the
back. Ribs slant diagonally down toward
the front.

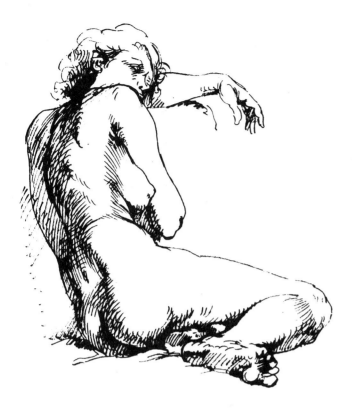

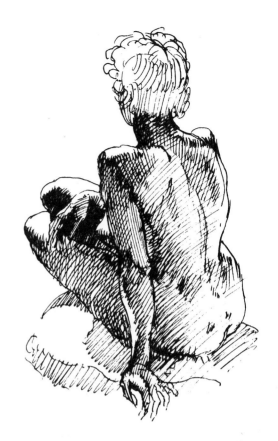

The light is from in front, and most of the modeling is done within the shadow area. The darkest part of the shadow is still nearest the light.

Top: The angle of the two dimples explains the angle of the hips. The hips and buttocks form a butterfly wing in perspective (see diagram above).

Right: Arms lock, supporting the leaning torso. The outside of the forearm attaches above the elbow, and the shoulders are pushed up and forward. The thigh is fleshy and flattens out from the body weight.

SIDE VIEW

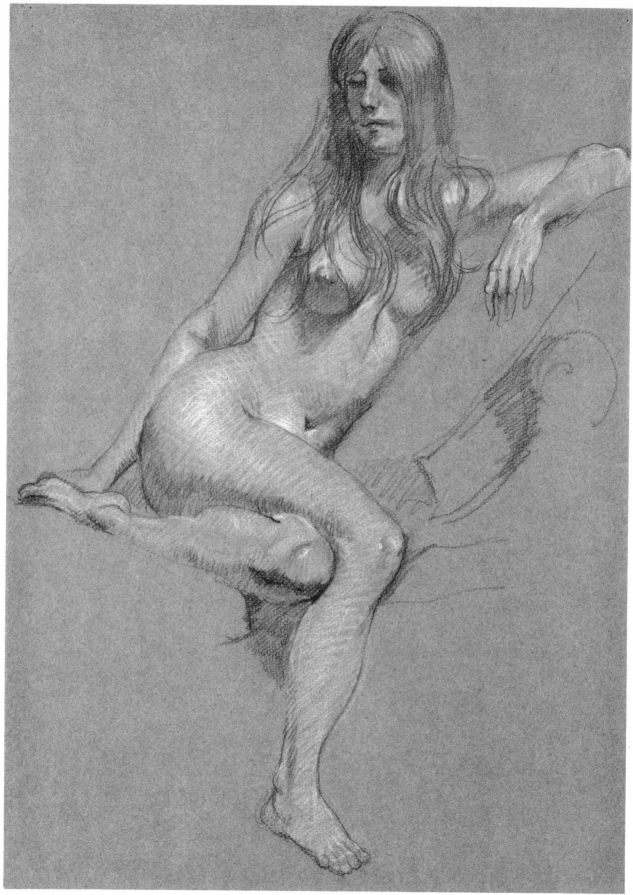

The model leans back, with weight on her side and left arm. The knees are established in the foreground, and the thighs overlap the hips, making the body recede.

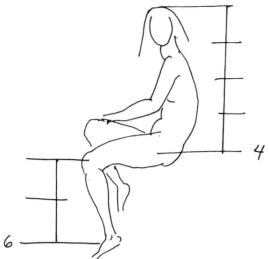

A thin wash has been applied to indicate
the shadow areas. The shadow accent
has been intensified by pen. The torso
and head are four heads high and the
lower part of the leg is two, making the
seated figure six heads high (see diagram
above).

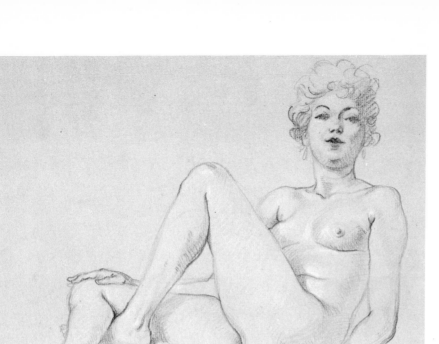

Drawing the underside of the foot automatically puts the leg in perspective. The cast shadow of the left leg pushes it forward. The hips are tilted and the body leans back.

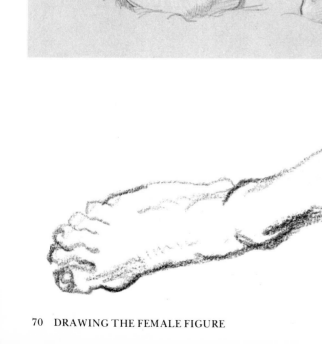

Less firm breasts and stomach indicate middle age. The shoulders are in front of the collarbones. The weight of the figure is on the back as well as the buttocks.

The overlapping lines at the knees ex-
plain which form is in front of which.
The inside of the elbow protrudes and
the muscle on the outside makes a high
silhouette.

The stomach divides down the middle, beginning at the navel. The chest muscles form the front wall of the armpit.

The toe next to the big toe is the longest. The outside of the foot rests flat on the floor. The slight curve on the front of the lower part of the leg is the shinbone. The back of the calf is fuller, with a more pronounced curve.

As the model leans forward, her breasts overhang her stomach. Each form is placed in space not only by overlapping lines, but by cast shadows. The arm throws a cast shadow on the breast and leg, and the breast throws a shadow on the fat roll of the belly.

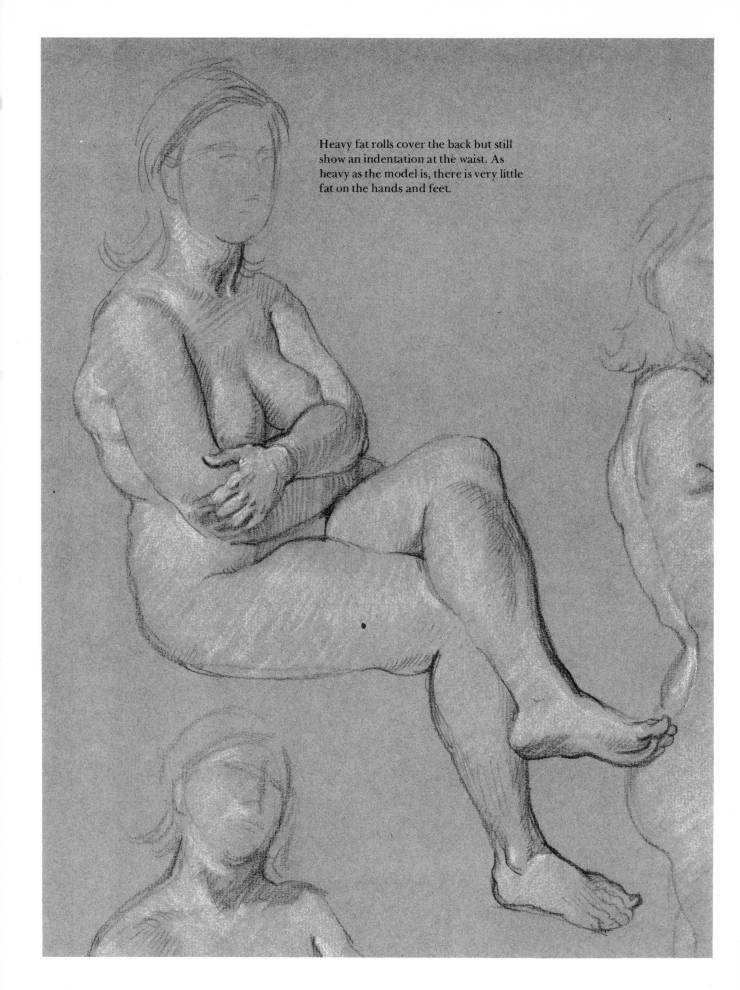

Heavy fat rolls cover the back but still show an indentation at the waist. As heavy as the model is, there is very little fat on the hands and feet.

The bent elbow is explained in this view.
The skin stretches tight over the fat of
the thigh and hip area.

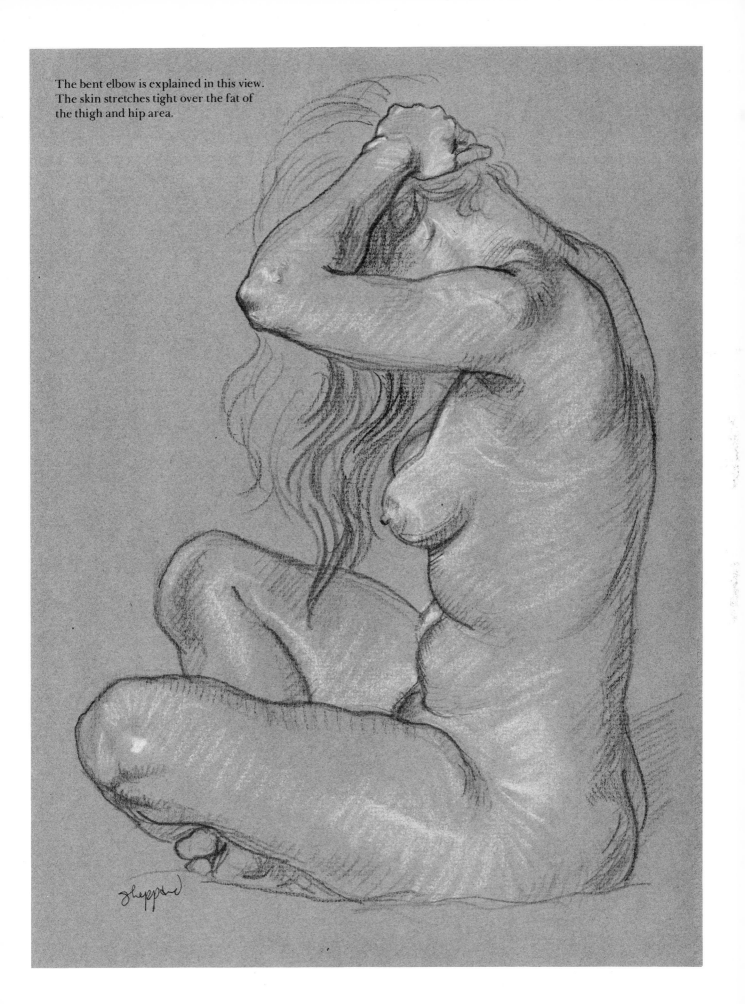

VII
THE KNEELING FIGURE

The weight of a kneeling figure is on one or two knees and sometimes the elbows or hands. In this position the lower part of the leg is usually foreshortened.

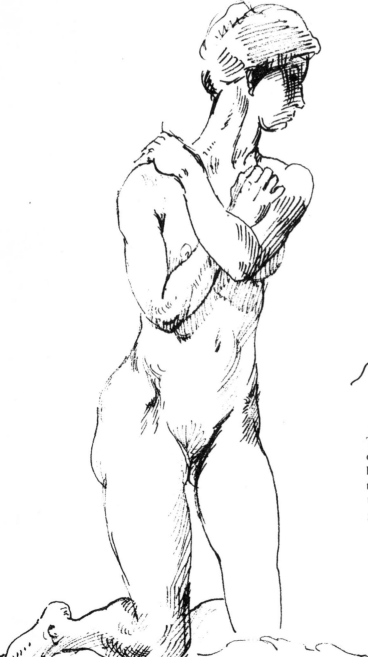

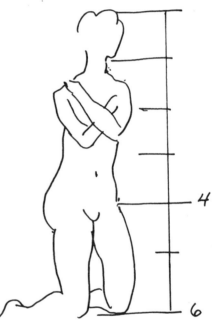

The shoulders and hips turn in different directions. The belly sits in the pelvic basin. The torso and head are four heads tall and the thigh is two heads, making the figure six heads altogether (see diagram above).

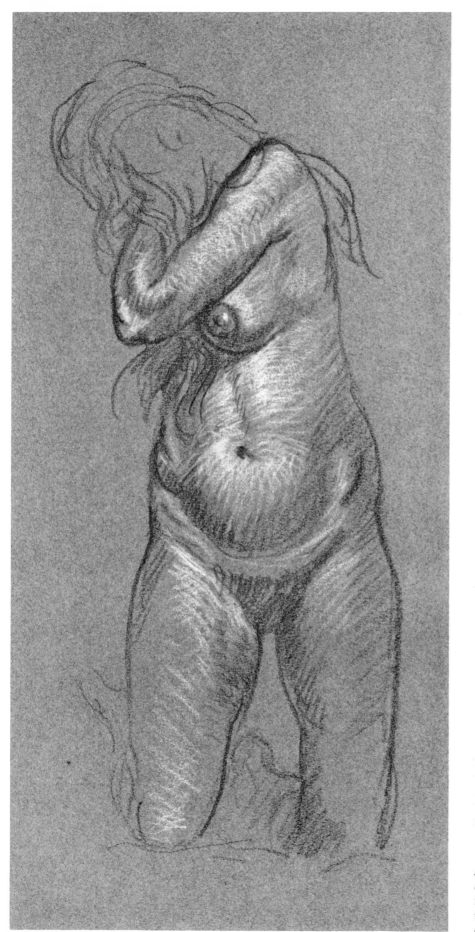

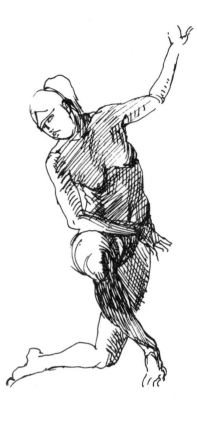

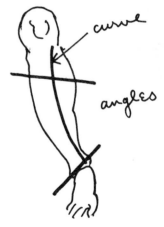

curve

angles

Top: The basic shape of the lower part of the leg is well explained here (see diagram above). The darker accents bring the one leg in front of the more lightly rendered one.

Left: The navel sits deep, and the ridges of the pelvis support the full belly. The inside of the thighs are full. A division in the muscles can be seen down the middle of the torso to the navel.

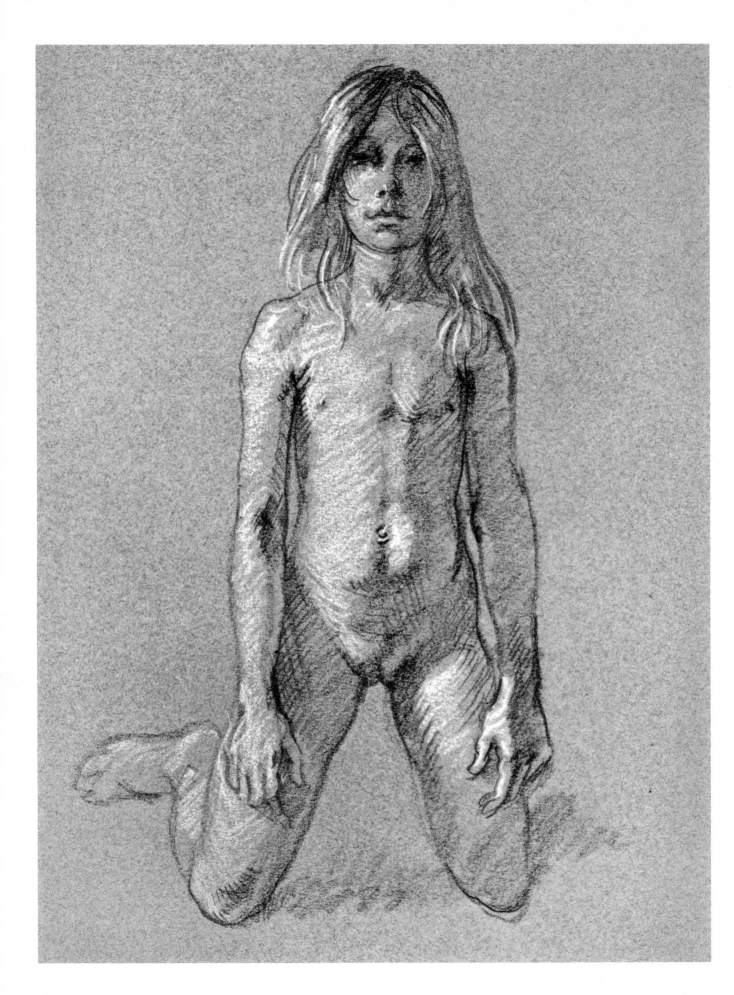

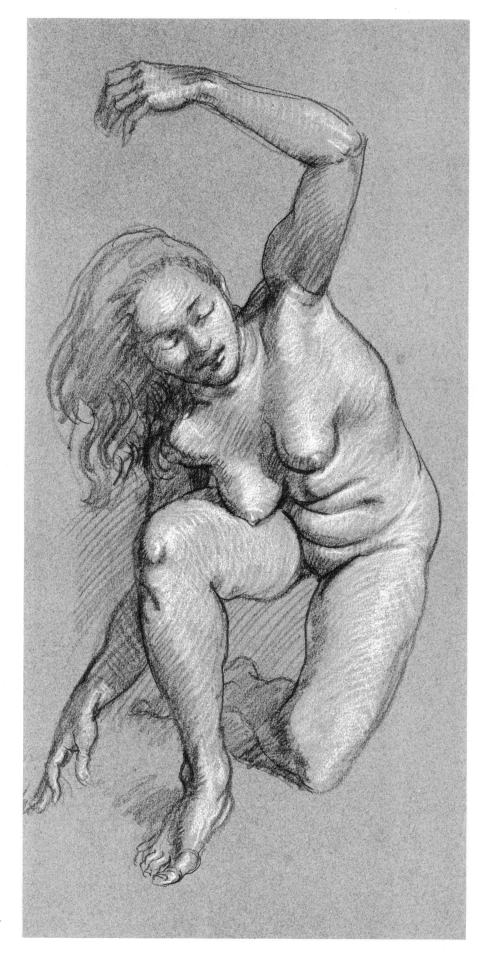

Left: The young girl's hips have not matured and are narrow. The division down the center of the torso is evident. Weight is evenly distributed.

Right: The weight is supported on the left knee and the right fingertips. The right arm is used as a balance. The cast shadow thrown from the right knee projects it forward.

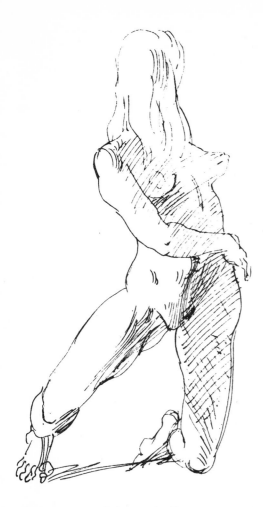

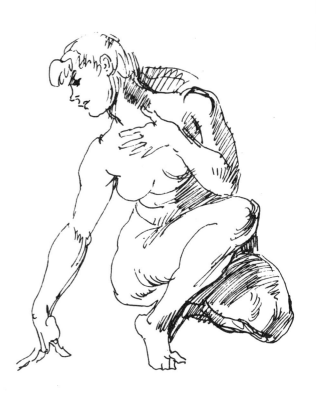

An unseen arm balances the figure. Some of the best poses are difficult to hold, so an artist must get the information down quickly.

Even though the shadows are just scribbled in, they still indicate the volume of the figure and the light source.

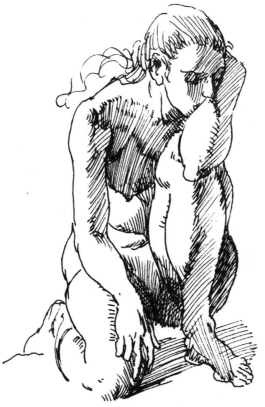

The arch is prominent on the inside of the foot. The shadow accents follow the direction of the form.

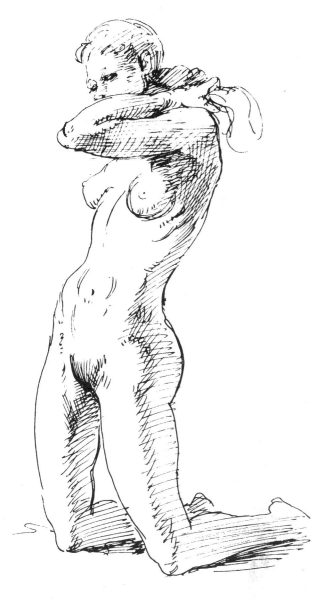

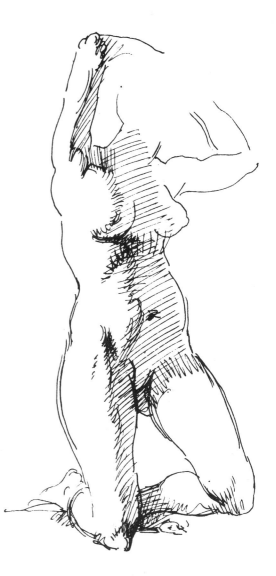

The head and belly are forward to balance the arched back. Bones are obvious in the elbow, ribs, pelvis, and knees.

The model is balanced on one knee and one foot. A pose like this must be drawn quickly. The shadow accent indicates the arch of the ribcage and the ridge of the pelvis.

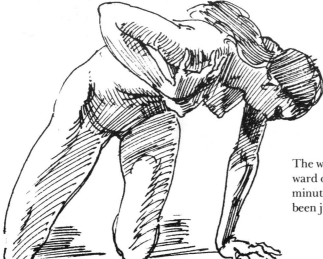

The weight of the figure is thrown forward onto the left arm. In this two-minute sketch, the light and shadow has been just roughly indicated.

BACK VIEW

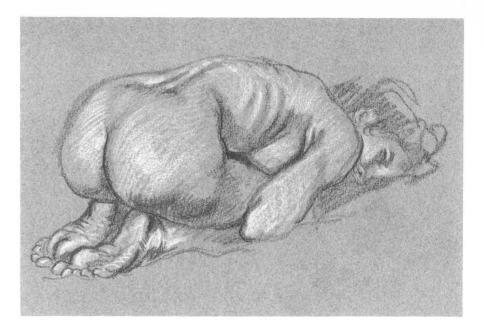

The triangular area above the buttocks crease is flat. The knees push against the chest, forcing the breasts outward.

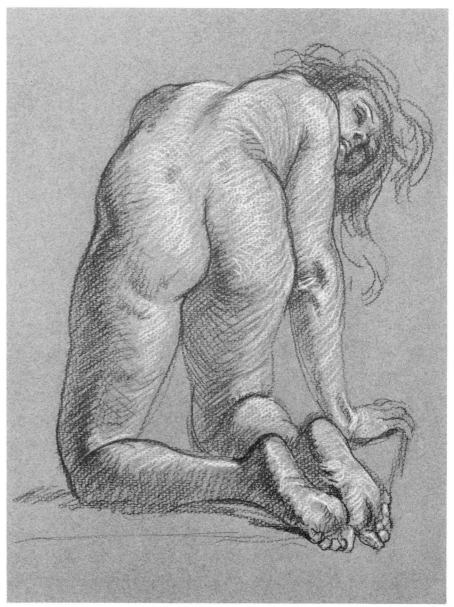

The backbone creates a deep furrow. The butterfly shape of the buttocks and hips is strong. Dimples in the thighs are caused by fat.

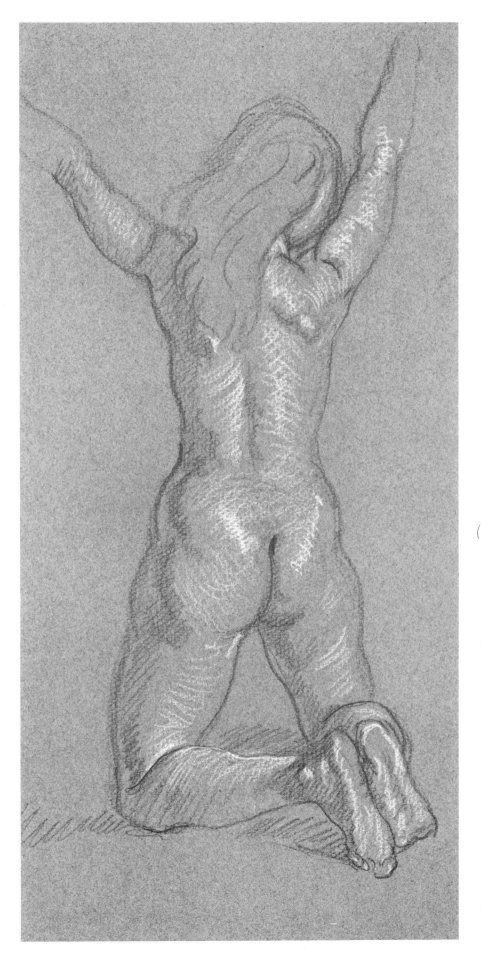

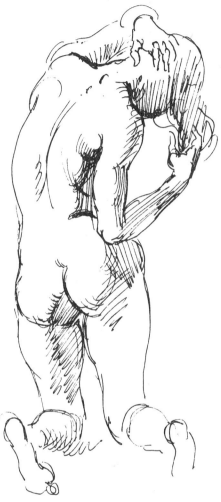

Above: In this quick sketch the shoulders and hips have opposite angles. The lines of the shadow follow the contour of the body.

Left: The shoulderblades angle out when the arms are raised. The hips are full and the waist is narrow and high.

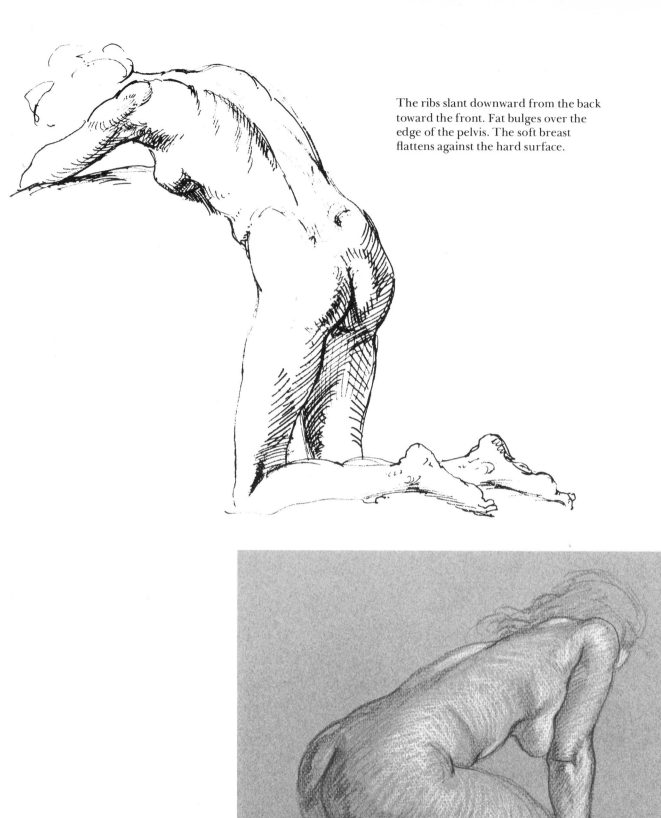

The ribs slant downward from the back toward the front. Fat bulges over the edge of the pelvis. The soft breast flattens against the hard surface.

The contours of the breast and arm change when they press together. The shoulderblade is pushed up by the pressure of the arm.

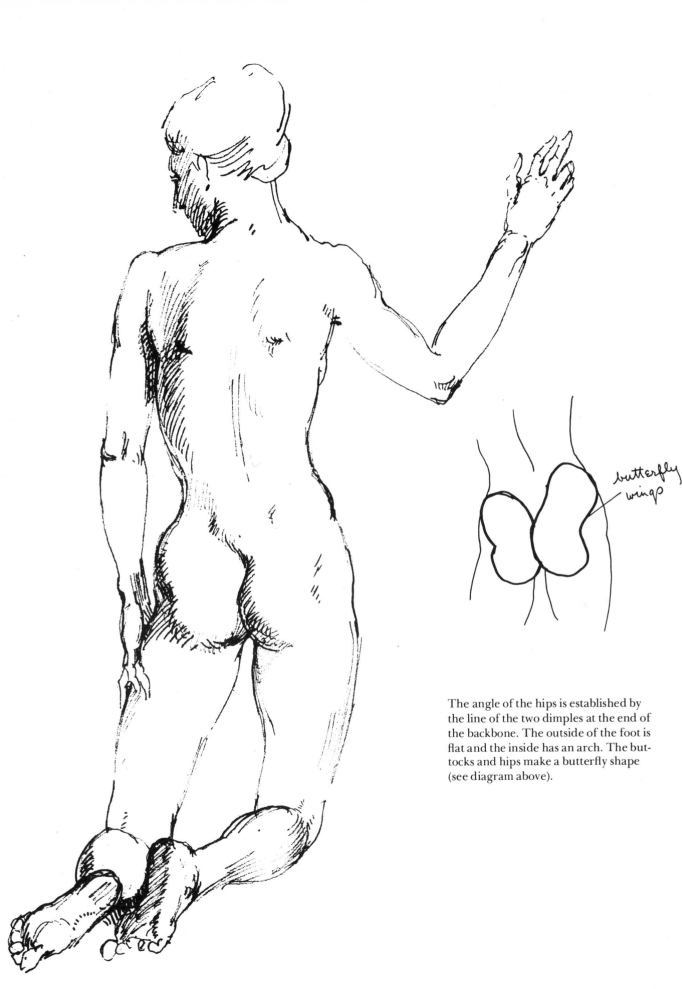

butterfly
wings

The angle of the hips is established by
the line of the two dimples at the end of
the backbone. The outside of the foot is
flat and the inside has an arch. The but-
tocks and hips make a butterfly shape
(see diagram above).

Females tend to have added weight in
the hips and thighs. There are also fat
deposits beneath the buttocks.

The immature hips of the young girl are
narrow and the thighs thin, like a boy's.
Cast shadows establish depth.

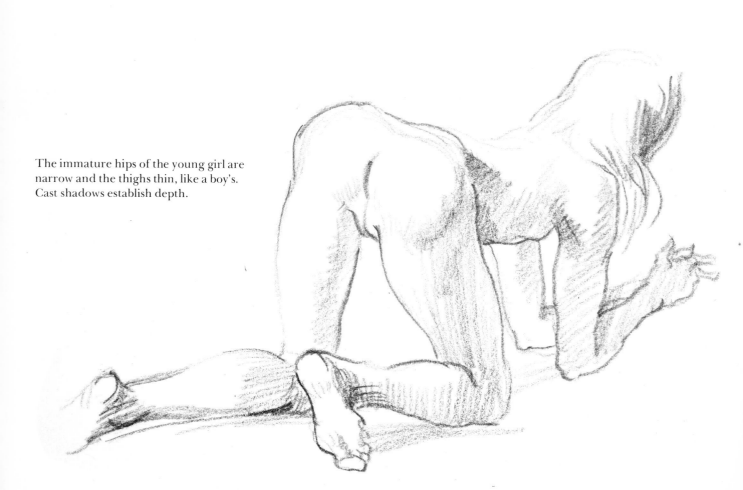

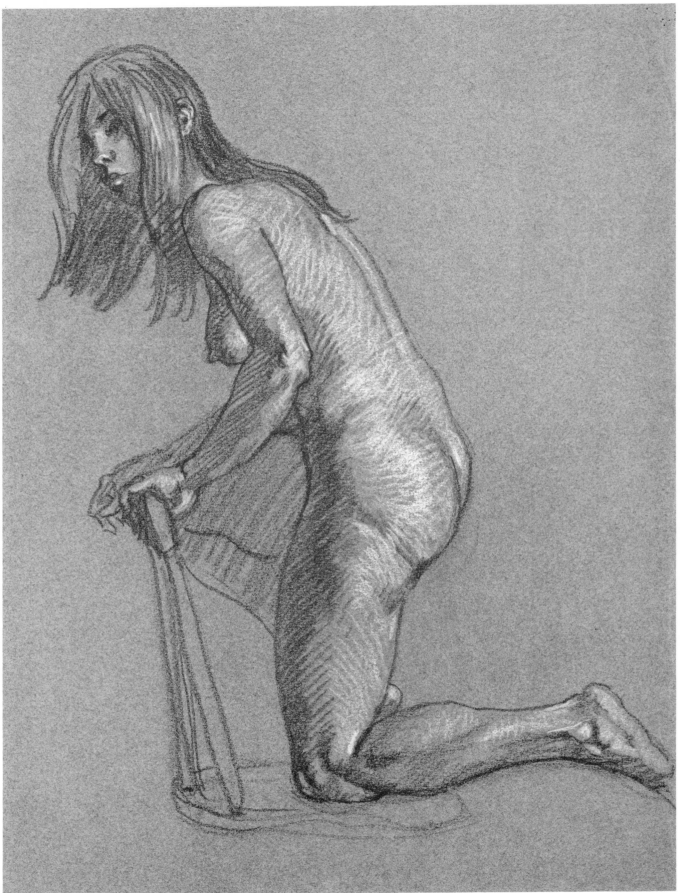

Bones are prominent in the elbow, pelvis, knee, and ankle. The white highlight emphasizes the fullness of the buttocks and the thighs.

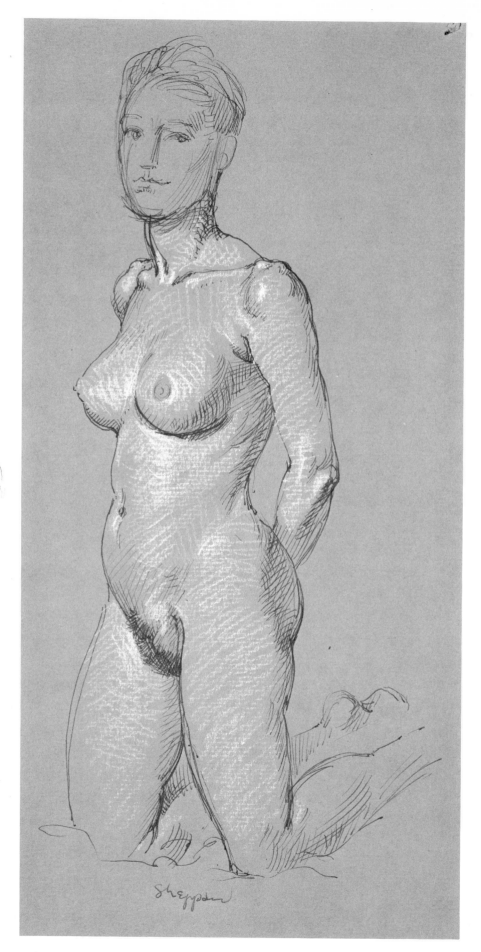

Above: The young girl twists her shoulders around, arching her back. Her weight is evenly distributed on her knees. Her arms keep her balanced.

Right: The cylindrical neck fits down into the torso behind the two collarbones. Small, fleshy folds protrude from beneath the arm. There is fat on the upper thighs.

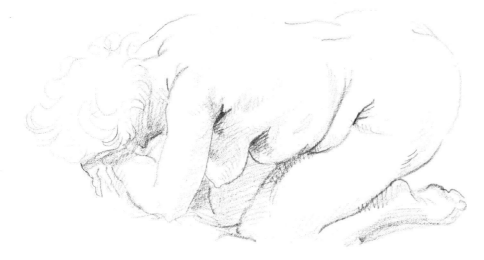

Left: Heavy model shows loose fat folding on itself. Small creases form at end of each bulge.

Below: Weight is put upon the arms, causing the elbows to cock out of line.

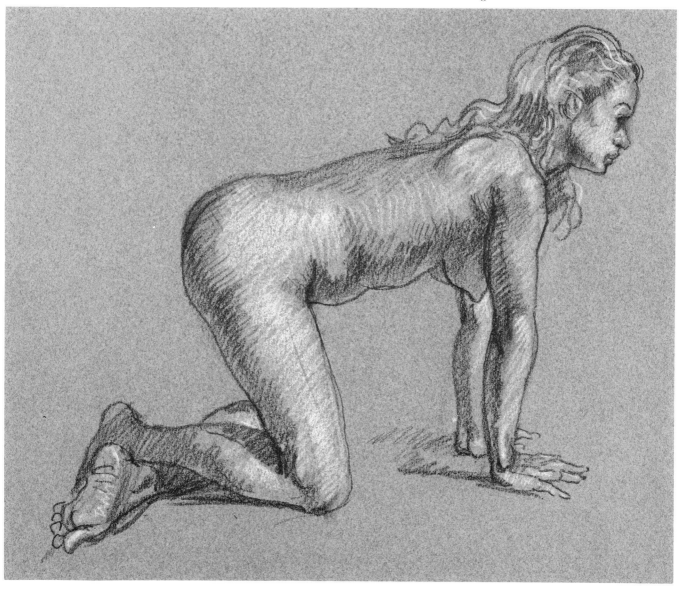

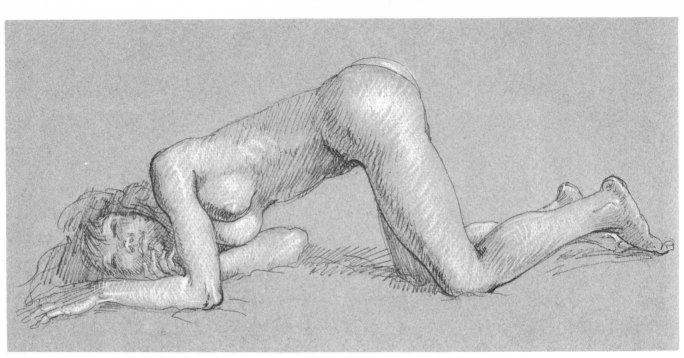

Weight is forced forward onto the arms. The breasts fall loose, pulled by gravity from their normal position.

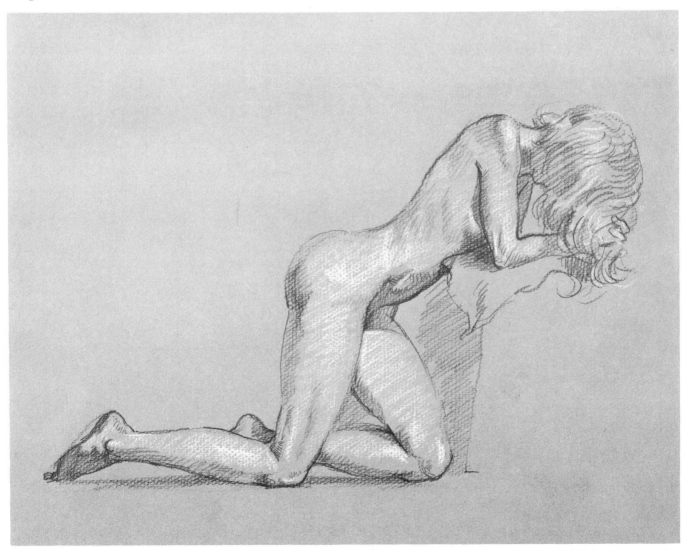

The weight of the figure is balanced on the knees and the elbows. The upper leg starts with the pelvis and buttocks area.

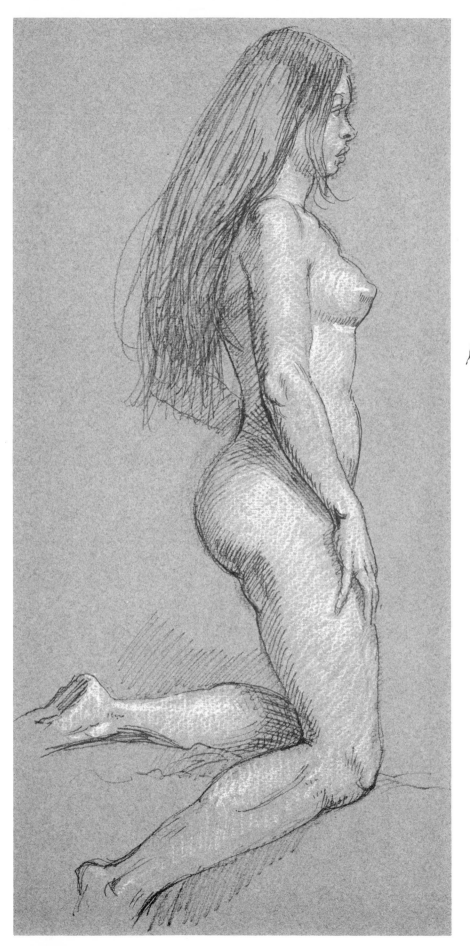

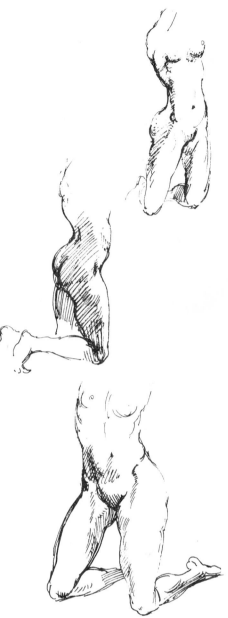

Above: The same pose seen from three different angles. The raised arms throw the ribcage forward. The pelvis thrusts forward, holding the belly.

Left: The bone on the little finger side of the hand is prominent next to the flat space of wrist. The nipple of the breast points upward.

VIII
THE CROUCHING FIGURE

The crouching figure is one of expectant action. The weight distribution is temporary. One feels that the figure is about to move or has just finished moving.

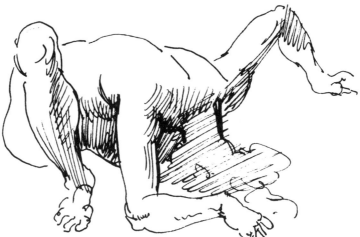

Quick sketch of a contorted position. The importance of establishing the shadow area is obvious; without it the figure would be difficult to understand.

The break in the shadow on the right thigh is caused by a diagonal muscle that divides the front of the leg from the inside.

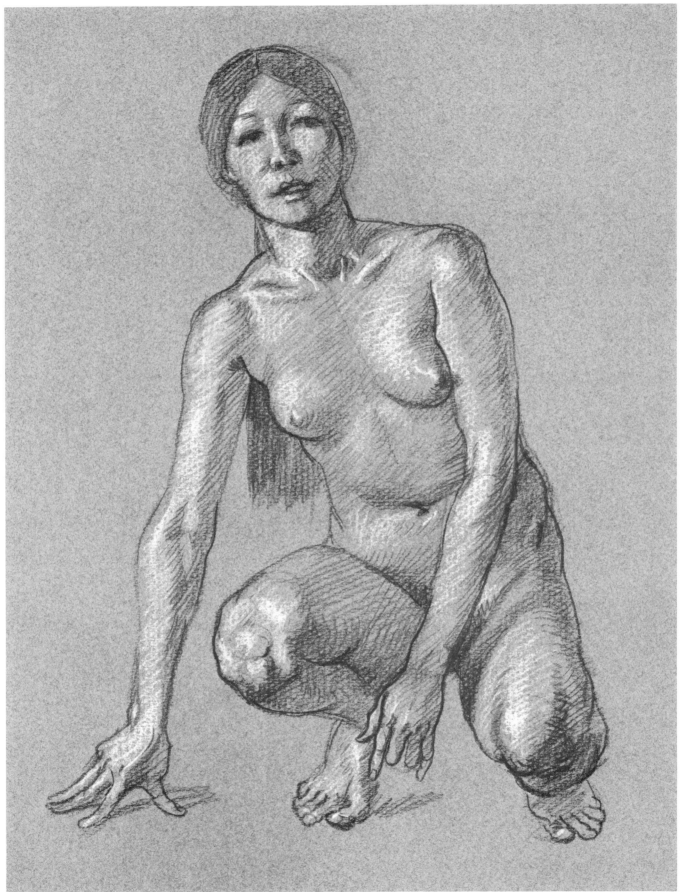

The forms of the upper left arm and breast push against each other, as do the upper and lower parts of the right leg, changing the normal contours. The dark outline and cast shadow bring the left hand forward.

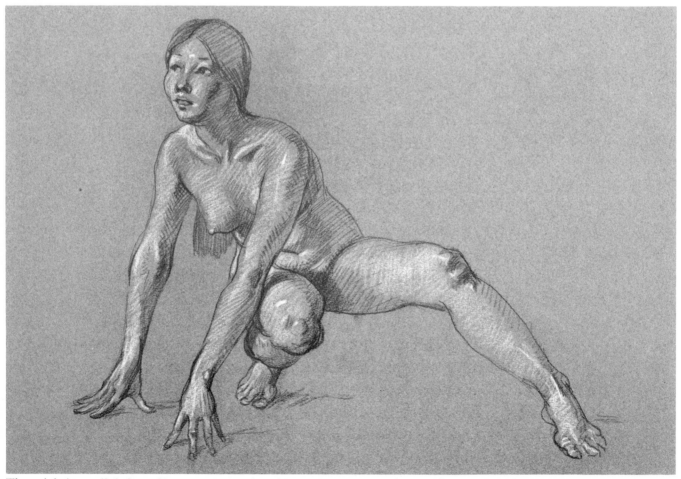

A continuous curved line is formed from the head through the extended leg to the toe (see diagram). The outstretched arms support the torso, and the bent leg acts as a spring.

The weight is equally balanced between the hands and feet. It is necessary to draw the kneecap in order to make the rest of the leg foreshortened.

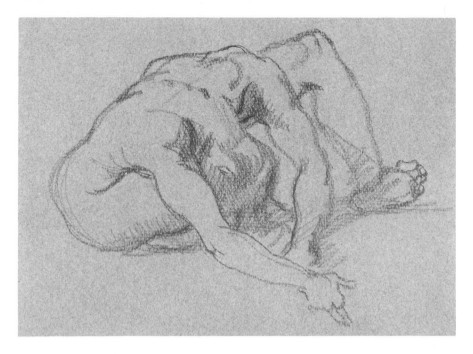

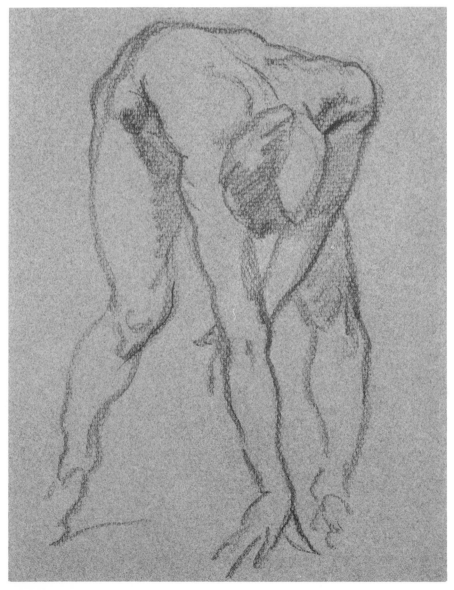

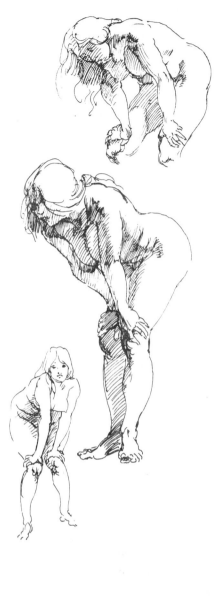

Above: The full breasts are pushed together by the locked arms. The arms support the leaning torso against the knees.

Top Left: The vertebrae of the backbone show between the two shoulderblades.

Bottom Left: In this quick sketch (less than a minute), only the essential lines have been put down. But attitude and proportion have already been established.

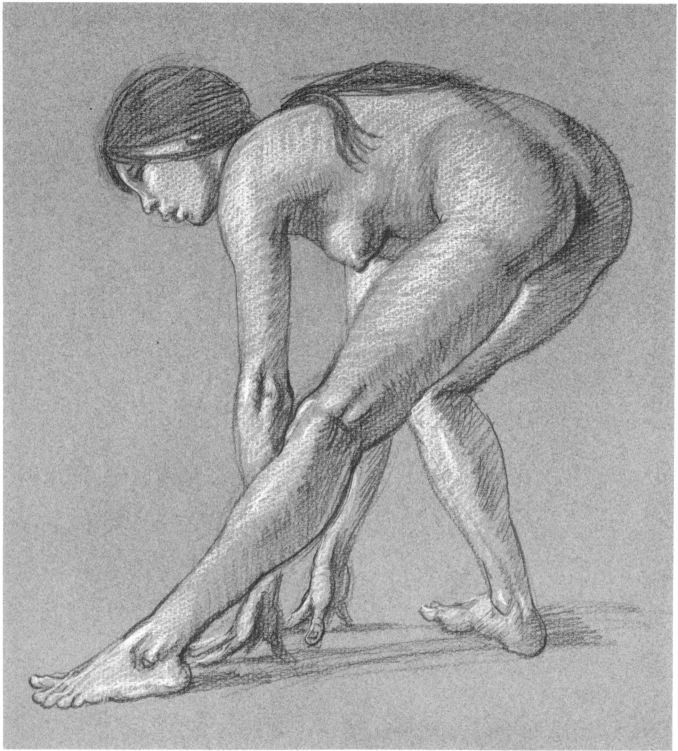

The tendons on the top of the ankle form a bridge between the leg and the foot (see diagram at left). The left knee is brought forward by a dark outline. The thigh above it is pushed forward by the highlight on the arm.

bridge of tendons

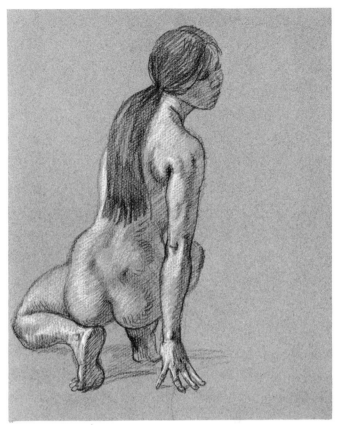

The triangular flat shape at the end of the backbone is evident. The outside of the foot is flat and the inside is arched.

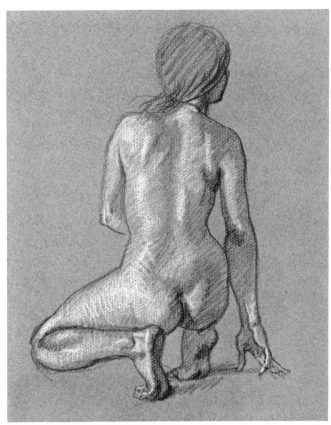

Weight is held by the toes, and the one hand is used for balance. The shoulders, ribcage, and shoulderblades turn together.

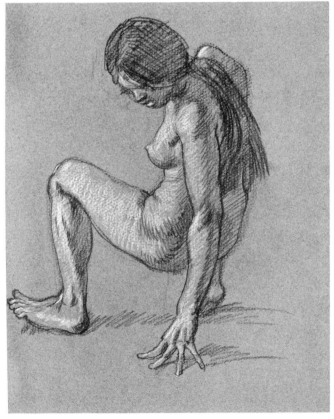

Weight is mostly on the extended fingers. The muscles of the arm and the calf harden as they help support the weight.

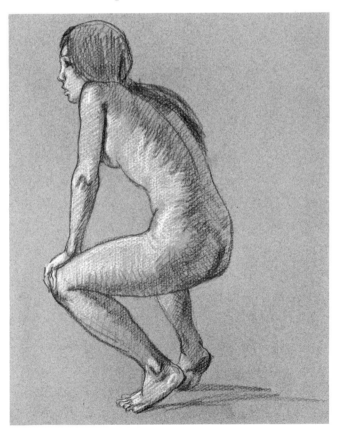

Model is completely balanced on her toes. The back arches forward and the downward slant of the ribs can be seen. The arms are locked against the legs.

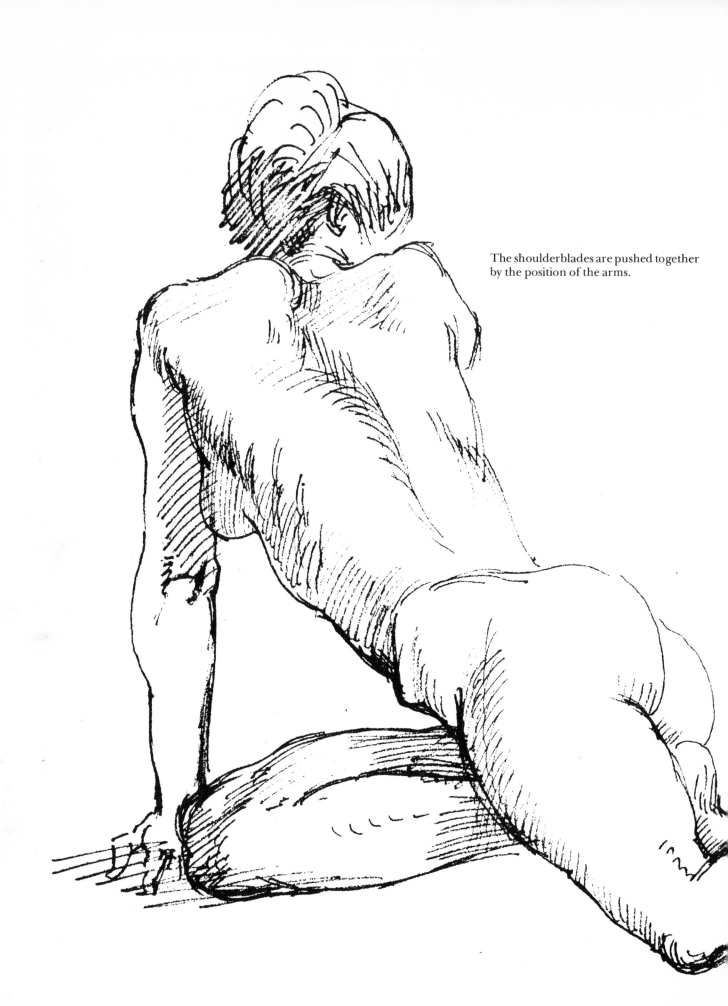

The shoulderblades are pushed together
by the position of the arms.

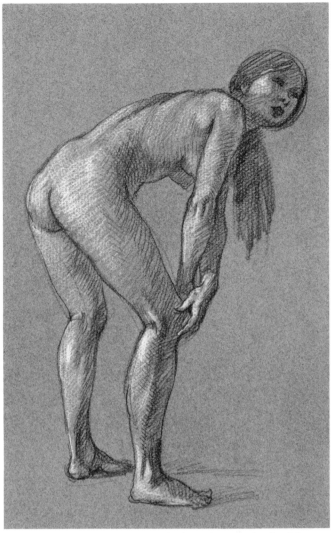

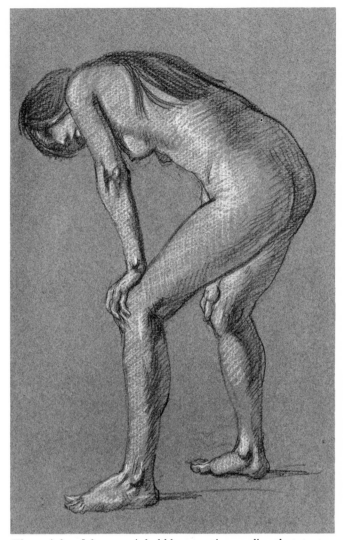

The calf muscles attach above the knee into the back of the upper leg. The model is balanced on both bent legs.

The weight of the torso is held by a continuous line that starts from the shoulders and descends down through the arms and into the lower part of the leg (see diagram below). The inside anklebone is closer to the front of the foot than the outside anklebone.

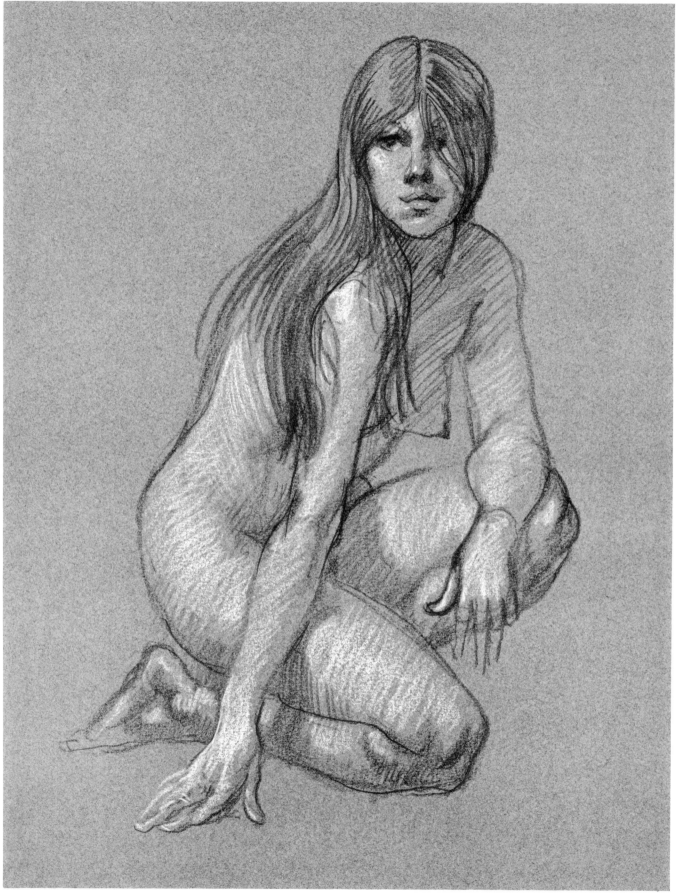

The cast shadow from the arm tells where the arm touches the thigh and how far it is from the bent knee. The flesh bulges in back of the bent knee.

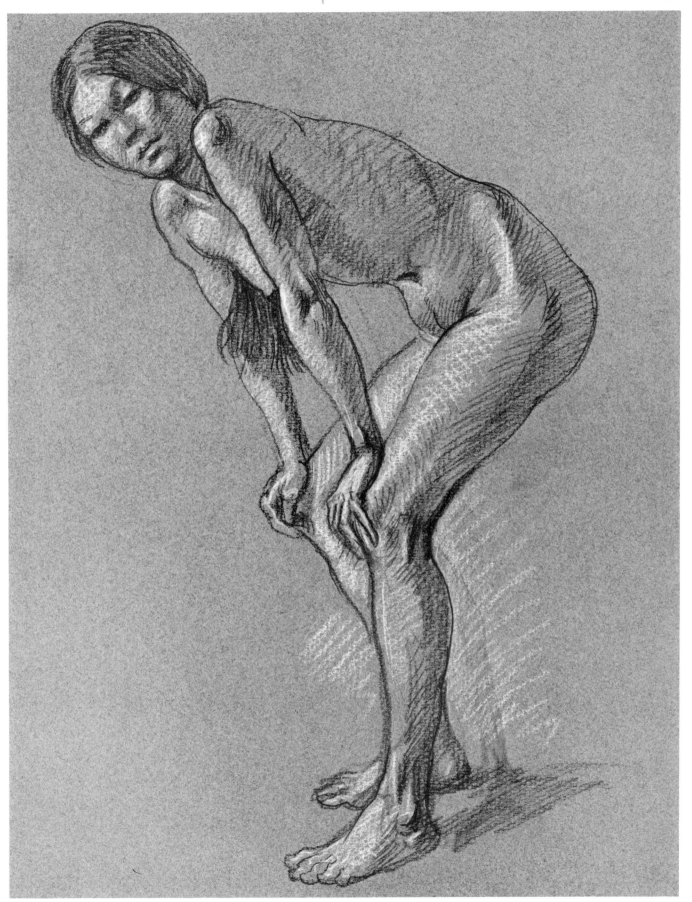

The braced arms support the body and push the shoulders forward. The pelvis is obvious at the hip, and the tendons at the knee and ankle are tensed.

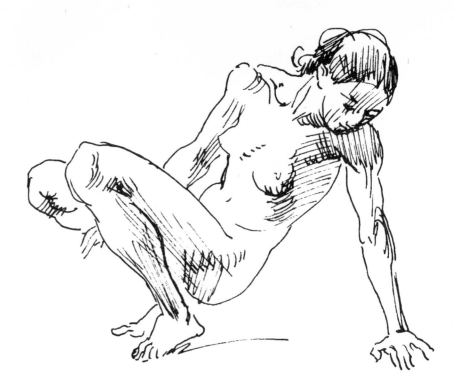

The model leans back, supporting herself on her left arm. This is a difficult pose, demanding quick execution.

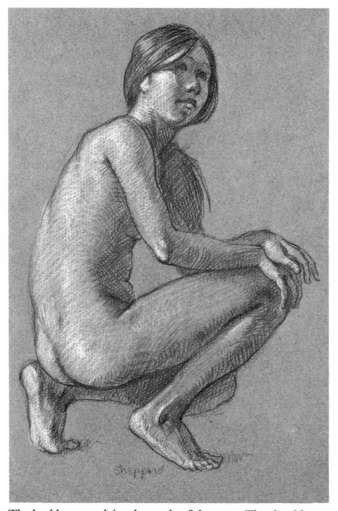

The backbone explains the angle of the torso. The shoulderblade protrudes. The two dimples at the base of the backbone are in line with the angle of the hips.

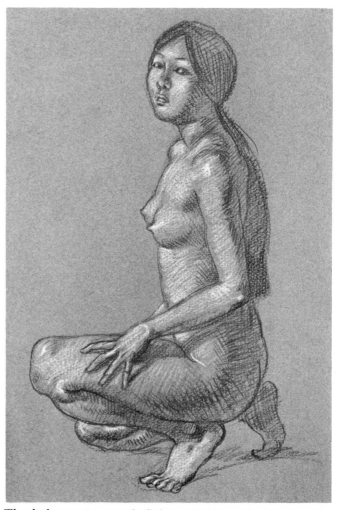

The dark accent next to the light on the hips and arm makes the form turn. The cast shadow places the form in space.

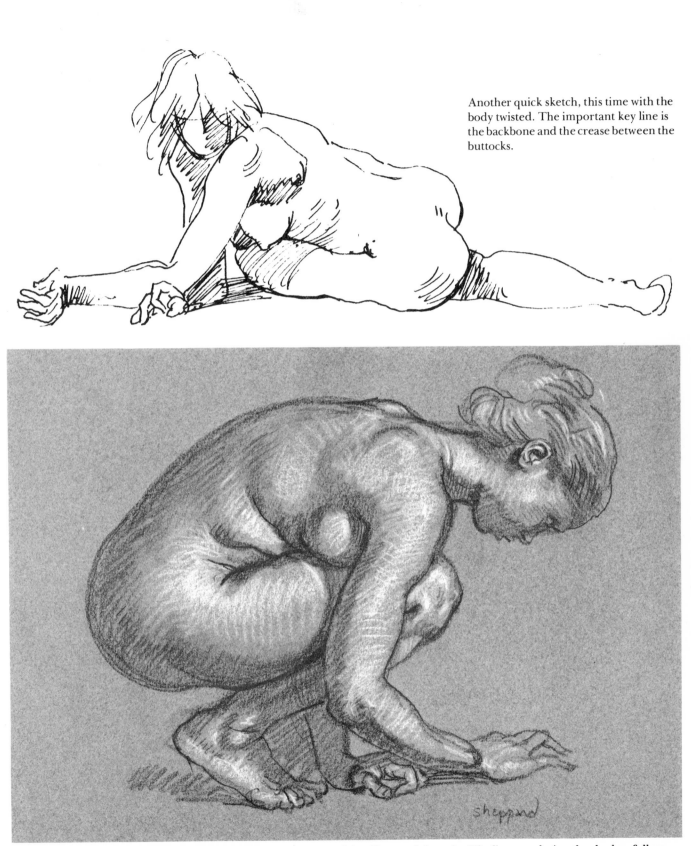

Another quick sketch, this time with the body twisted. The important key line is the backbone and the crease between the buttocks.

The foreshortening of the forearm is explained by the drawing of the elbow and the wrist. The lines rendering the shadow follow the contour of the form. The muscles attached to the shoulderblade insert into the arm.

IX
THE RECLINING FIGURE

The reclining figure seems more difficult to draw than the standing one. Foreshortened limbs and difficult angles make it almost impossible to use the eight-heads measurement effectively. Instead, comparative measurements should be used. Find the middle of the figure and then subdivide it and work out to the extremities.

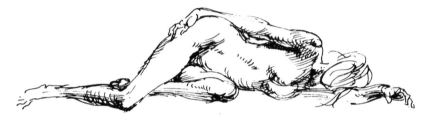

The contours against the supporting surface are all flattened out. The breasts hang to the side because of the gravity pull.

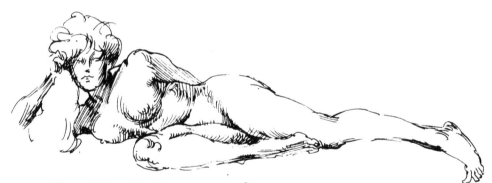

The model's weight flattens out her soft breasts. The foot presses against the thigh. Directional lines in the shadow indicate the shape of the form.

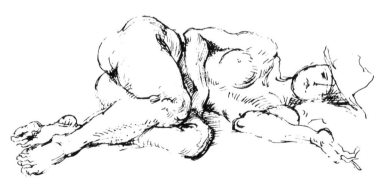

The knee is well explained and brought forward by the cast shadow. A series of overlapping forms make the foreshortened thigh work. The weight of the model is suggested by the lines of the pillow.

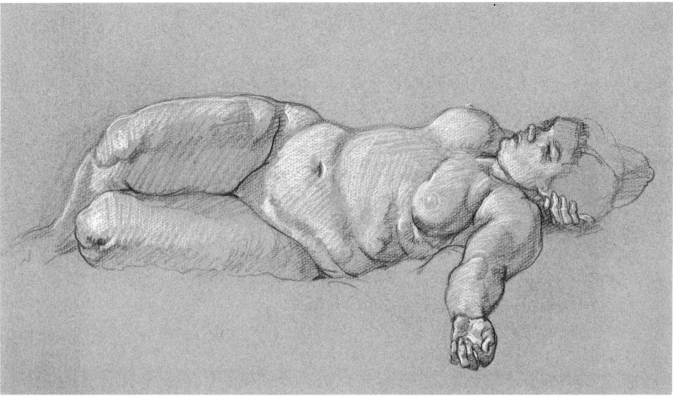

Heavy breasts hang to either side and fat covers the pelvis and ribs. I drew the hand first on the foreshortened arm and then connected the arm to the torso.

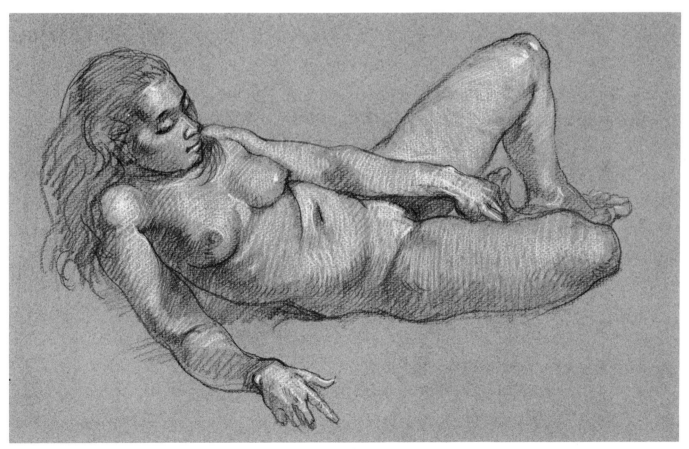

Shoulders and hips turn in different directions. The bone on the little finger side of the wrist is more prominent but shorter than the bone on the thumb side. The right breast casts a shadow on the upper part of the right arm, keeping the arm back in the same plane as the torso.

The model leans back and supports her-
self on one arm. The ribs show beneath
her breasts. The nipples point out, away
from the center of the torso.

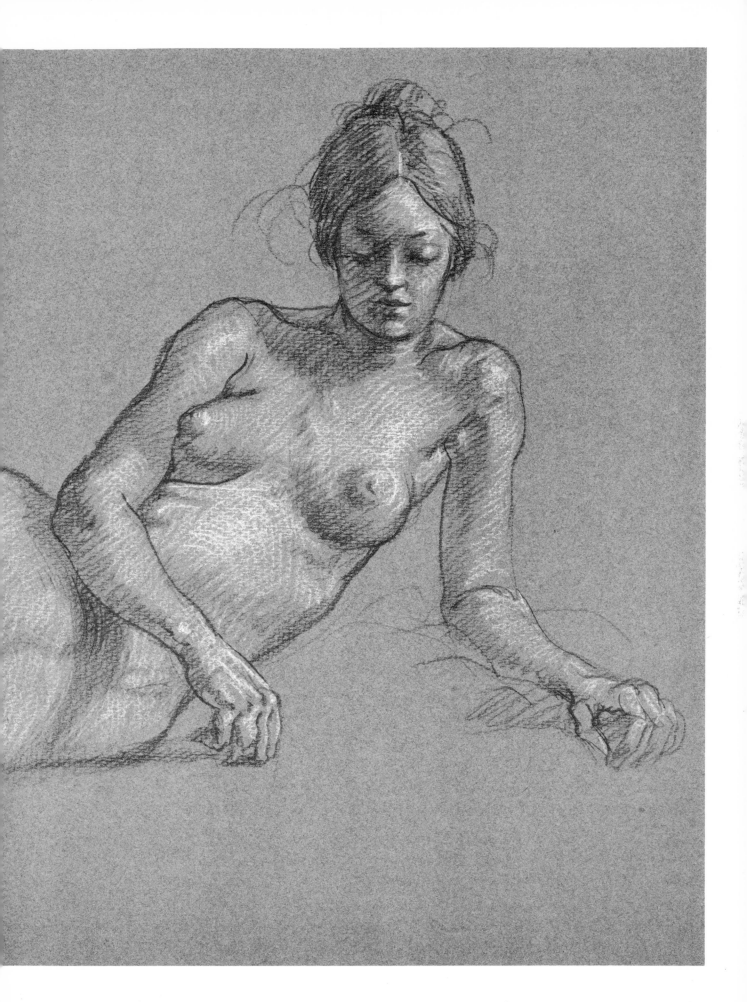

BACK VIEW

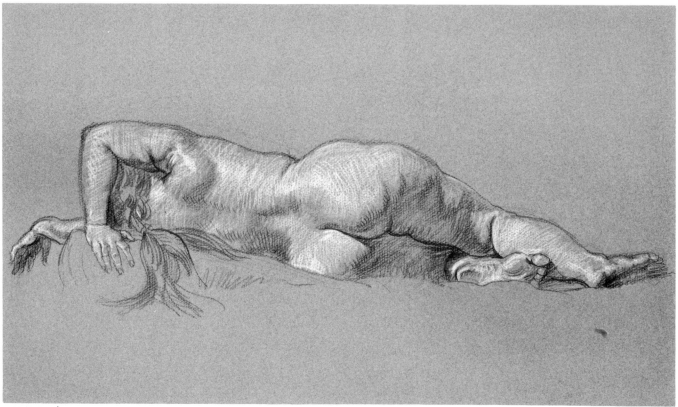

The basic female form stays the same even when the model is heavy. Dimples appear on the backs of the thighs from fat. The middle finger is always the longest finger.

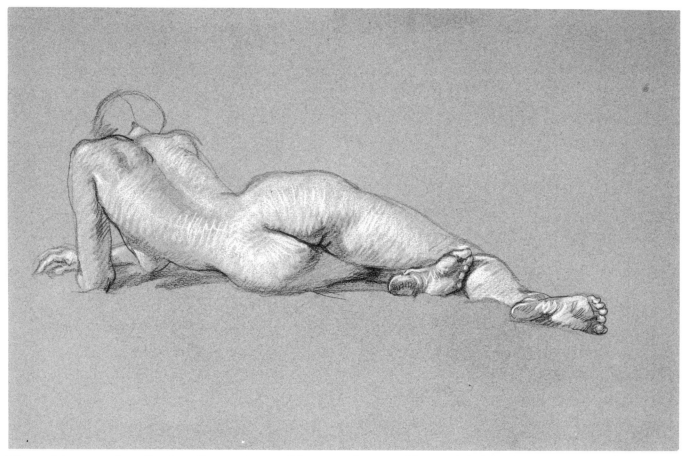

The model supports herself on her elbows as the top of the torso twists away. The twist is indicated by the line of the hips overlapping the back. On the underside of the foot the arch is seen on the inside; the outside is straight.

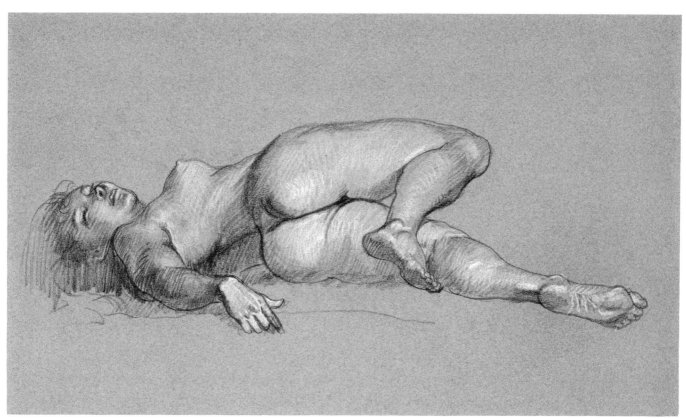

Contorted positions such as this are difficult to draw but are often worth the effort. The hips and shoulders are turned in opposite directions as far as they will go.

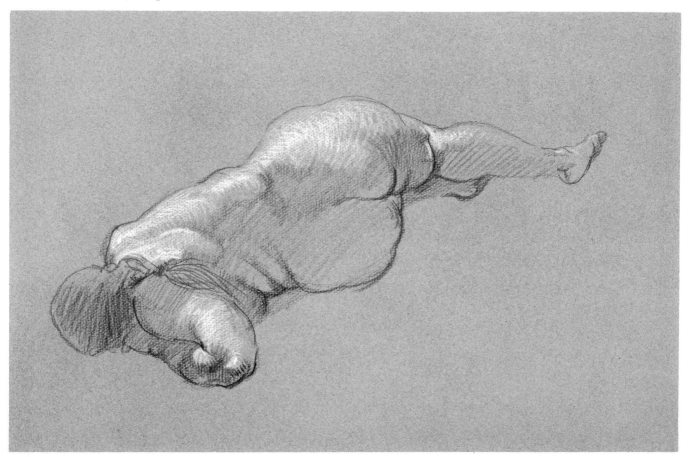

Bones disappear in this heavy model. The elbow is brought forward by strong rendering and dark accents. The highlights are in the center of the halftone and not on the edge.

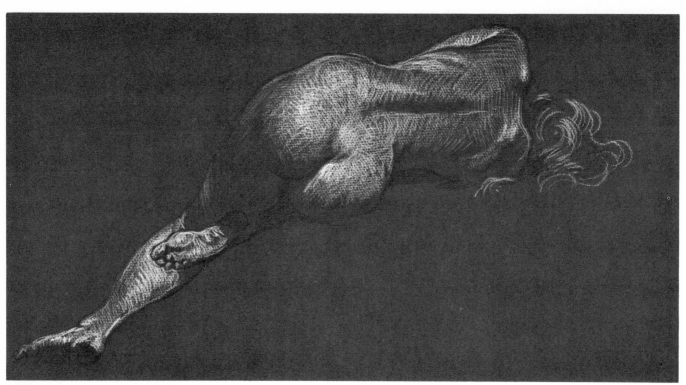

The strong light on the buttocks and lower part of the leg makes the shadowed thigh recede.

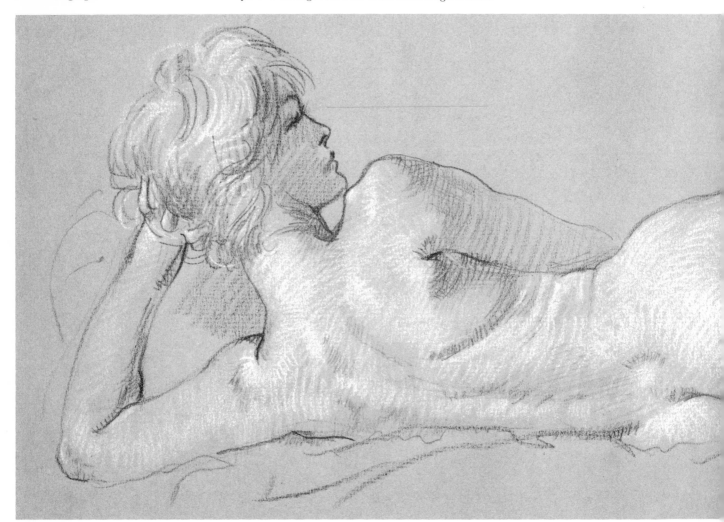

Folds at the waist are caused by the twisting of the shoulders and hips in different directions.

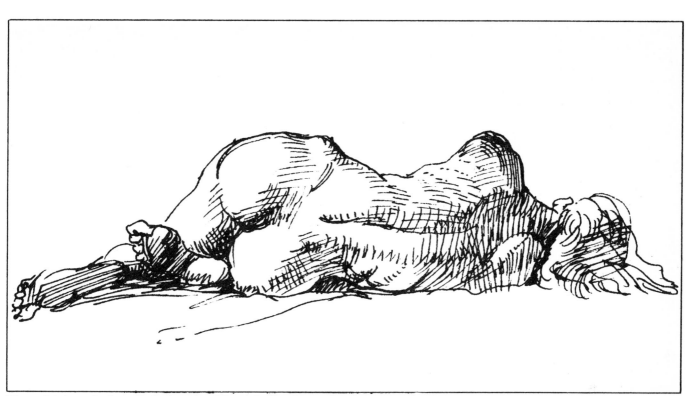

The pelvis is pushed up. Only the sole of the right foot is seen, but it suggests the complete position of the hidden leg.

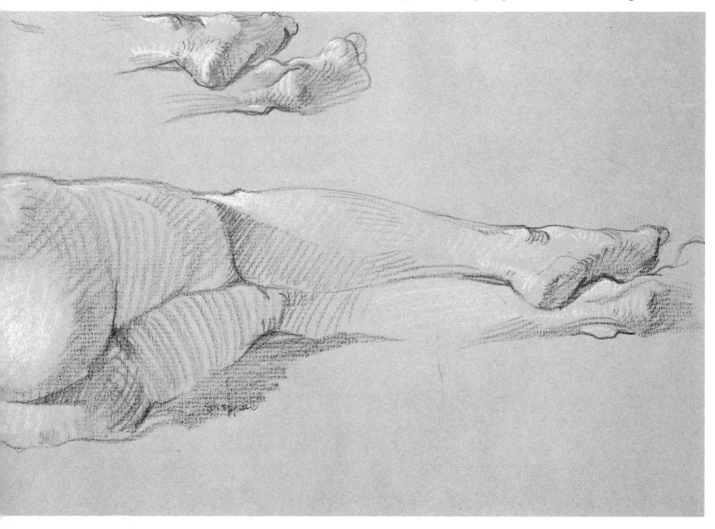

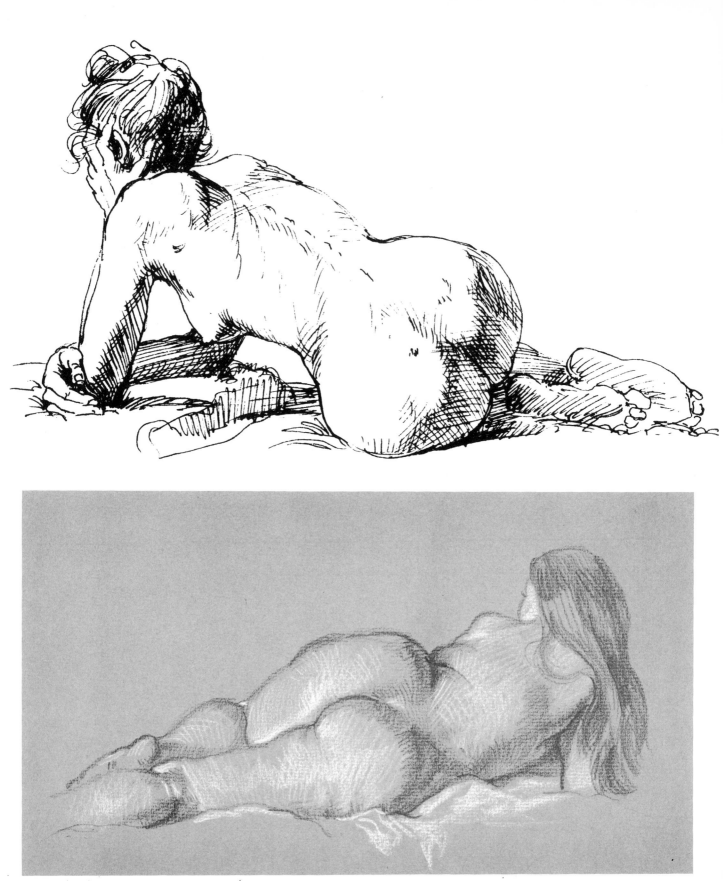

Top: The ribs and backbone are prominent. The raised knees force the buttocks into a smoother round shape.

Above: The highlight on the back thigh pushes the front thigh forward. In this position the buttock fold disappears.

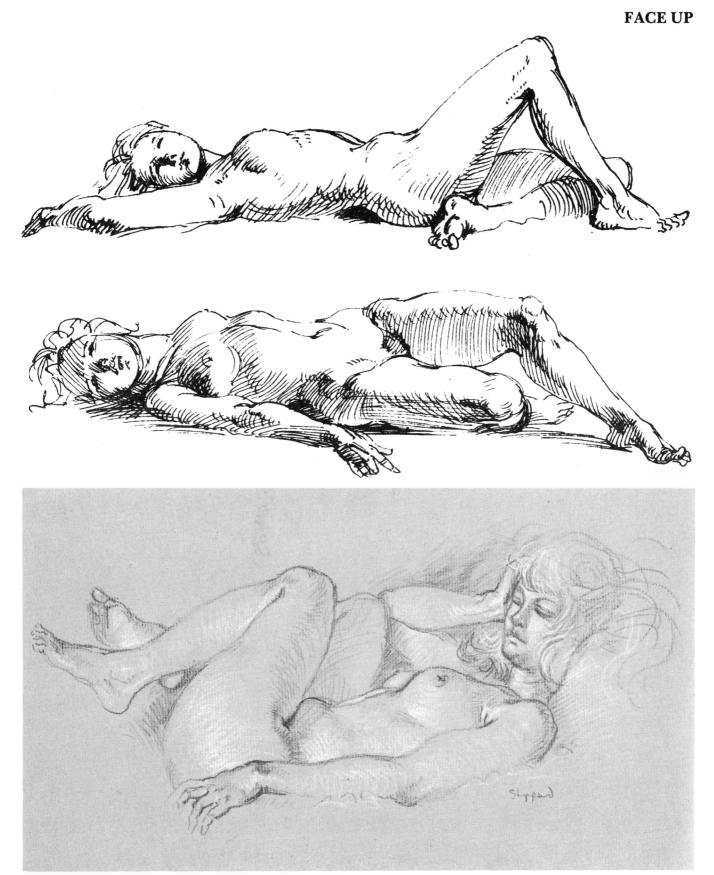

Top: The body flattens from its weight against the supporting surface. The foreshortened foot presses into the buttocks.

Center: The front of the torso is divided in half by a line down the breastbone to the navel. When a model lies on her back, her stomach flattens and her breasts fall to either side.

Above: The soft flesh has a pneumatic quality as it folds against itself on the stomach and the leg. The broken line of the supporting surface shows the weight of the figure.

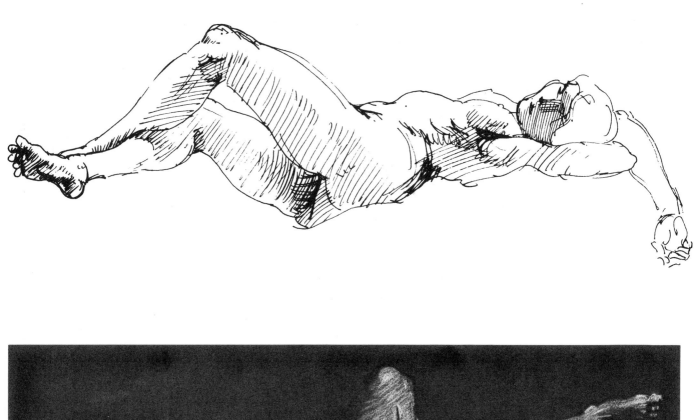

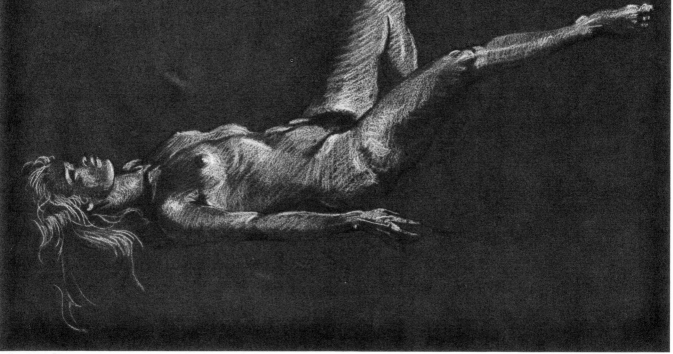

Top: The underside of the buttocks suggests the hip angle. The bottom of the ribcage makes a higher silhouette than the breasts, indicating an arched back.

Above: The division down the center of the torso is evident. The ribs protrude and the stomach sinks between the ridges of the pelvis.

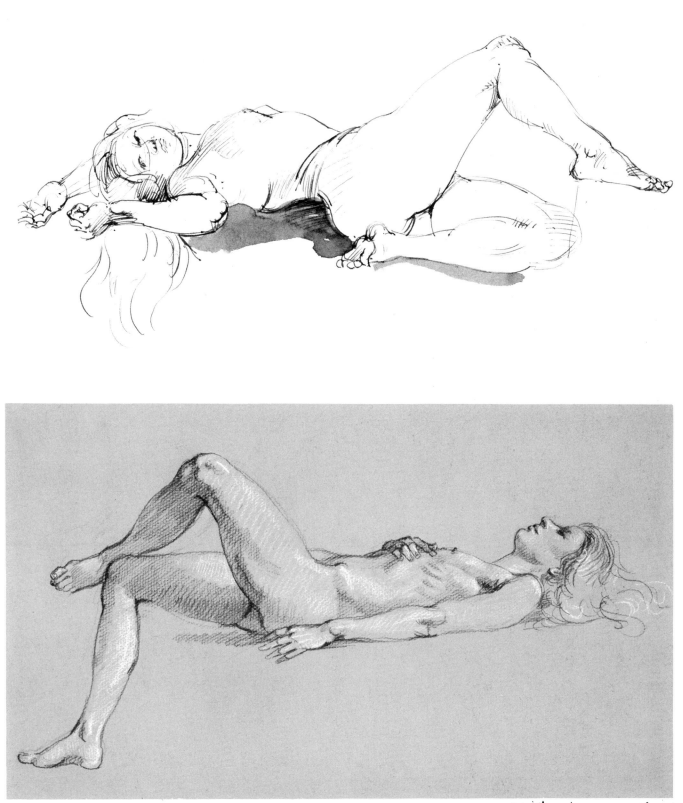

Top: In this quick sketch, form is explained by outline and overlapping lines.

Above: Muscles attaching to the ribs are shown running diagonally across the chest. The chest muscles extend out into the arm. The wrist makes a small bridge between the hand and the forearm (see diagram at right).

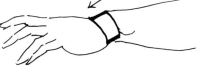

wrist makes a small bridge or ramp between the arm and hand

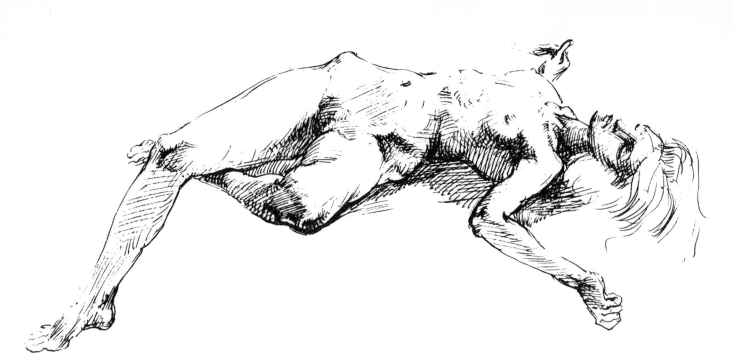

The two ridges of the pelvis protrude and the stomach lies flat between them. The ribcage is obvious beneath the breasts.

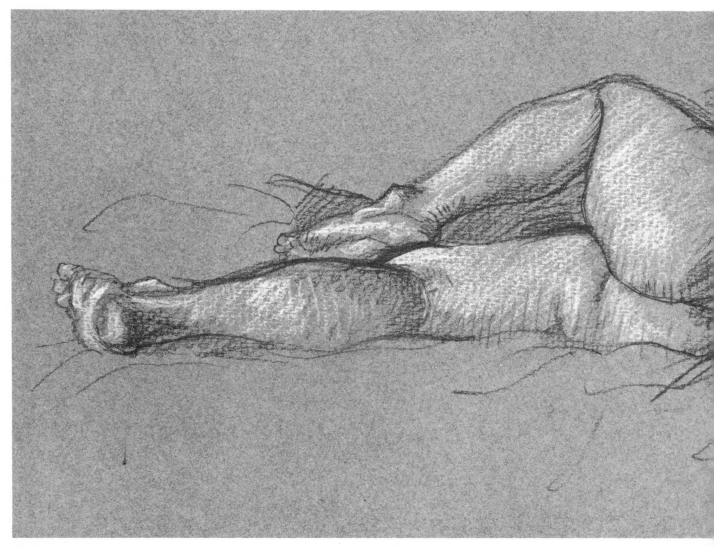

The bottom of the left foot helps define the foreshortening of the leg. The line of the backbone makes the body turn.

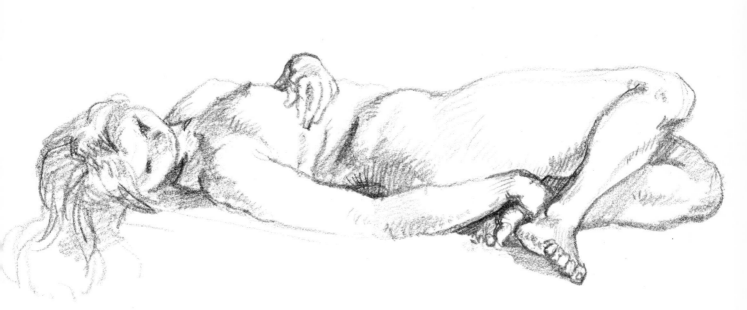

The back is arched and the hips twisted, forming folds at the waist.

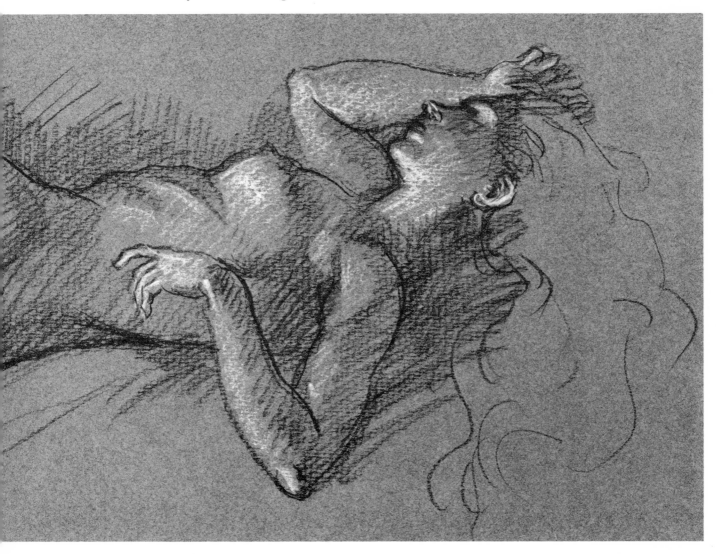

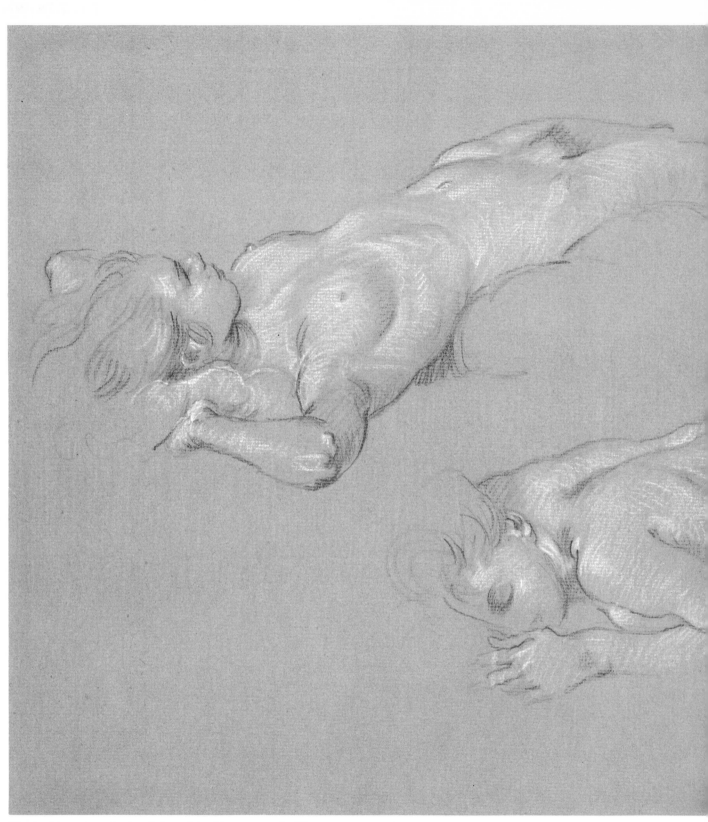

The backbone is arched and the pelvic ridges protrude. The
breasts and the belly flatten out.

The middle knuckle of the fist is the highest point in the arch of knuckles. When the knees are bent, the kneecaps are prominent.

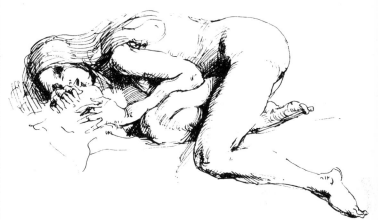

The cast shadow from the left leg pushes it out from the rest of the body. The line running between the arm and right leg explains which form is in front of the other. Elbow, leg, and knee change position and overlap each other.

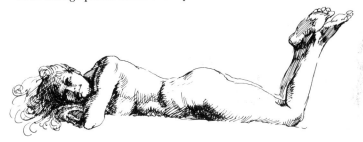

On a heavy model, the excess weight hangs from the body and flattens out against the supporting surface.

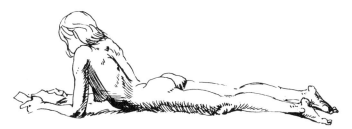

The upper part of the torso is bent up and held by the arms. The legs and the pelvic area lie flat against the supporting surface. The buttocks are flexed because of the extended legs.

The fullness of the buttocks is indicated by the highlight. The ribs angle down from the backbone toward the front of the torso. The body weight is felt as it presses into the bed.

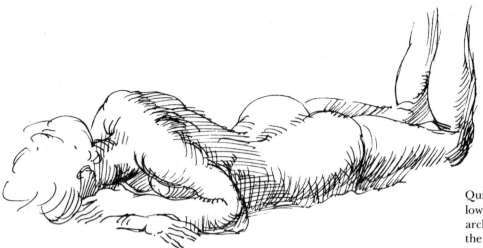
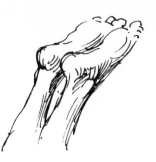

Quick sketches show shoulderblades following the arms. The backbone is arched. Tendons appear on the back of the thigh, raising the lower leg.

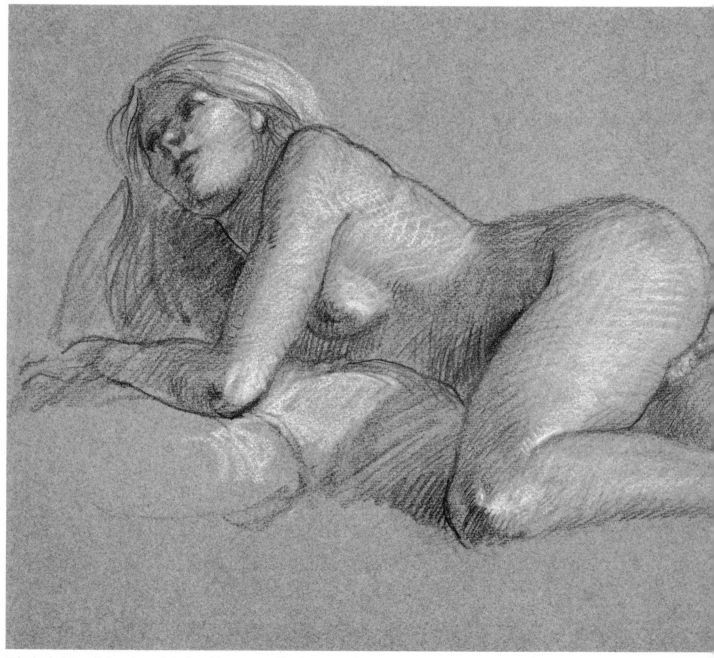

The body has a slight twist and the head is supported by the unseen arm.

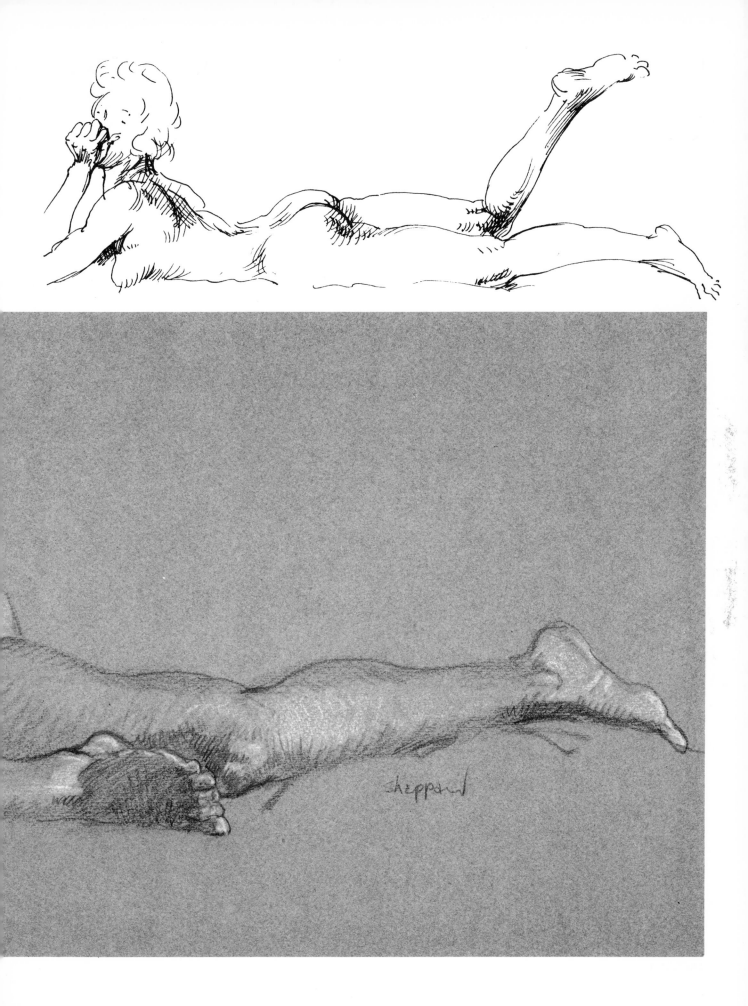

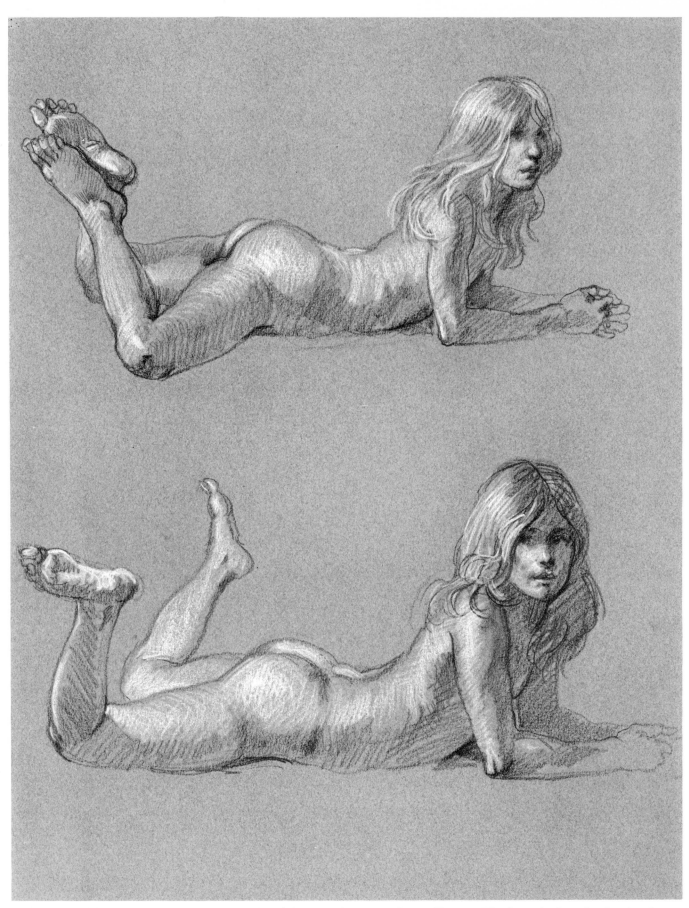

In the young girl, the shapes are the same as in the adult except for proportion and breasts. The figure is about five heads tall instead of eight.

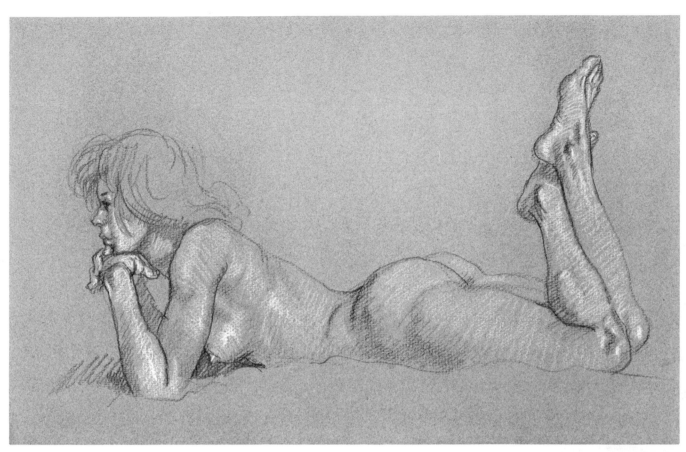

The head and torso are supported by the arms. The lower part of the legs are bent back as far as they will go.

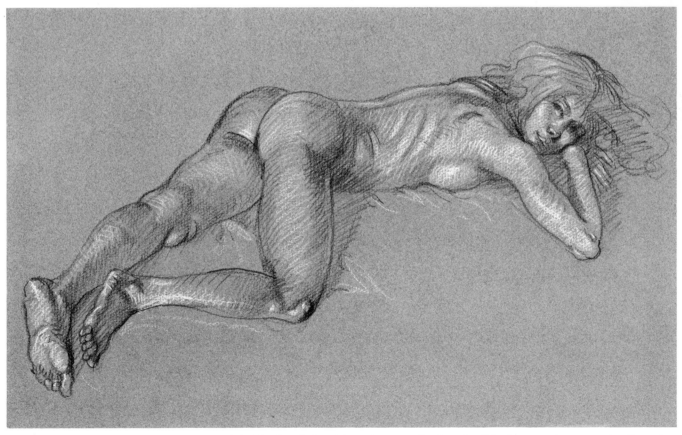

The foreshortened legs explain the angle of the hips in relationship to the torso. On the sole of the foot are creases starting from the arch.

X
THE FORESHORTENED FIGURE

In the foreshortened figure we have to think of forms as sections, one in front of another. Most measuring devices do not work. It is important not to work too close to the subject, as a near object appears larger than normal, creating a distortion. Intersecting and overlapping lines become important and cast shadows help push one form in front of another. Finding the parts of the body that align with each other is necessary in drawing the foreshortened figure.

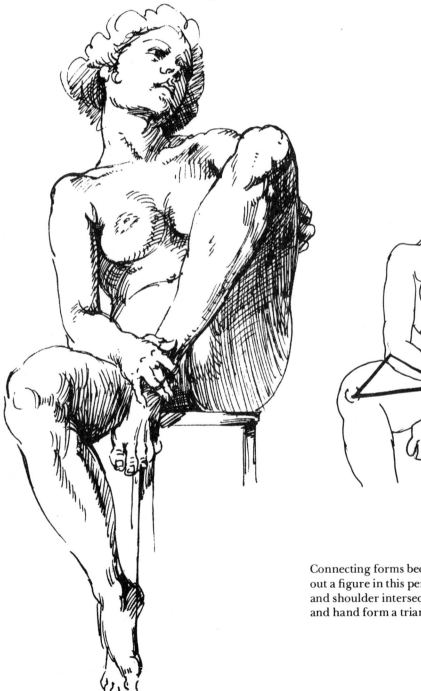

Connecting forms become important in laying out a figure in this perspective. The left knee and shoulder intersect. The right knee, elbow, and hand form a triangle (see diagram above).

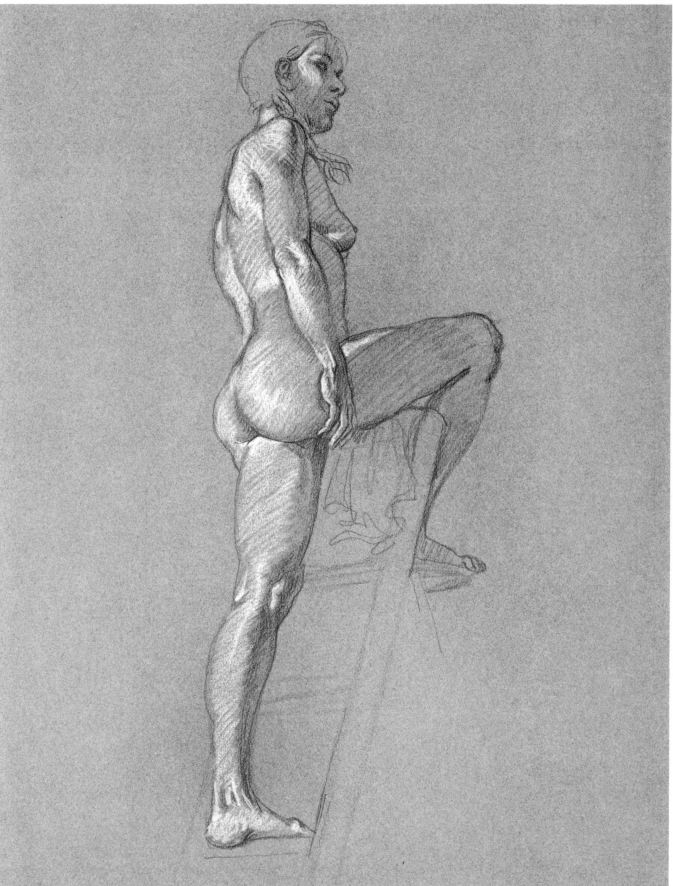

The angle used for the head, shoulders, hips, and back of the leg is the same. This gives the feeling that we are looking up and that the right side is higher than the left.

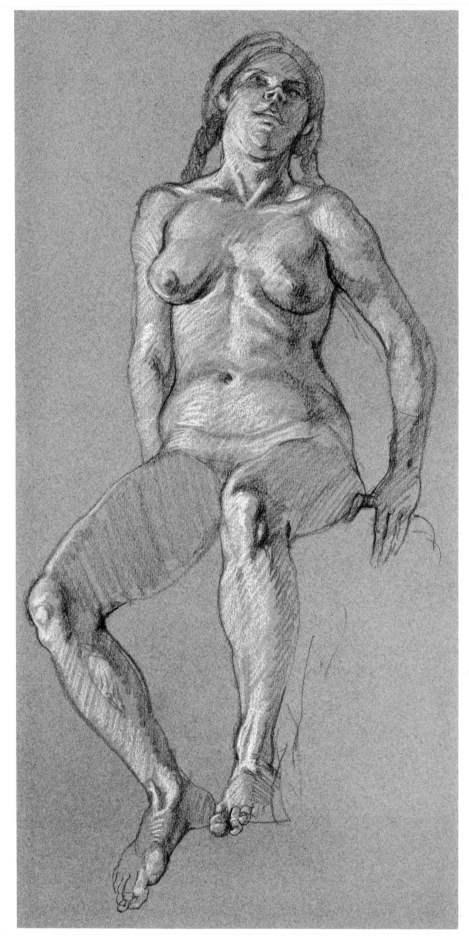

Drawing the underside of the chin and
nose puts the head in perspective. Once
the left knee is established, it is easy to
align the hand and pubic area. The right
leg is drawn after the two extreme points
— the two feet together and the hips —
are determined (see diagram above).

Opposite Page: The viewpoint is ex-
plained by drawing the underside of the
thigh and chin. The foot is slightly en-
larged because it is closer. (This can eas-
ily be overdone and create an undesir-
able photographic "fish-eye lens" look.)

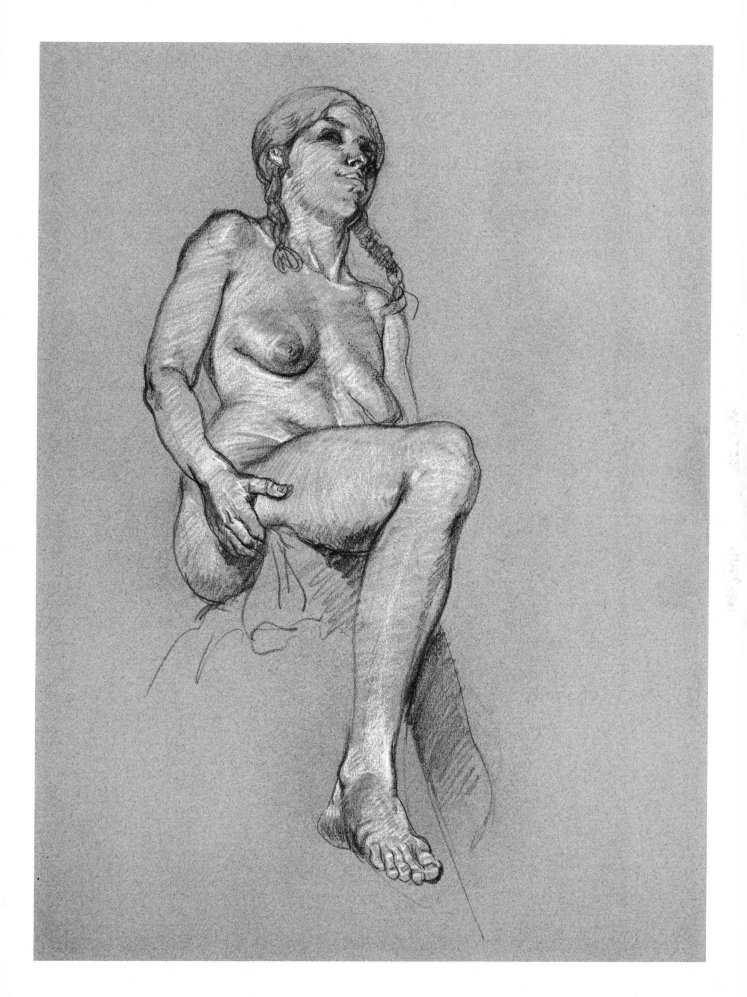

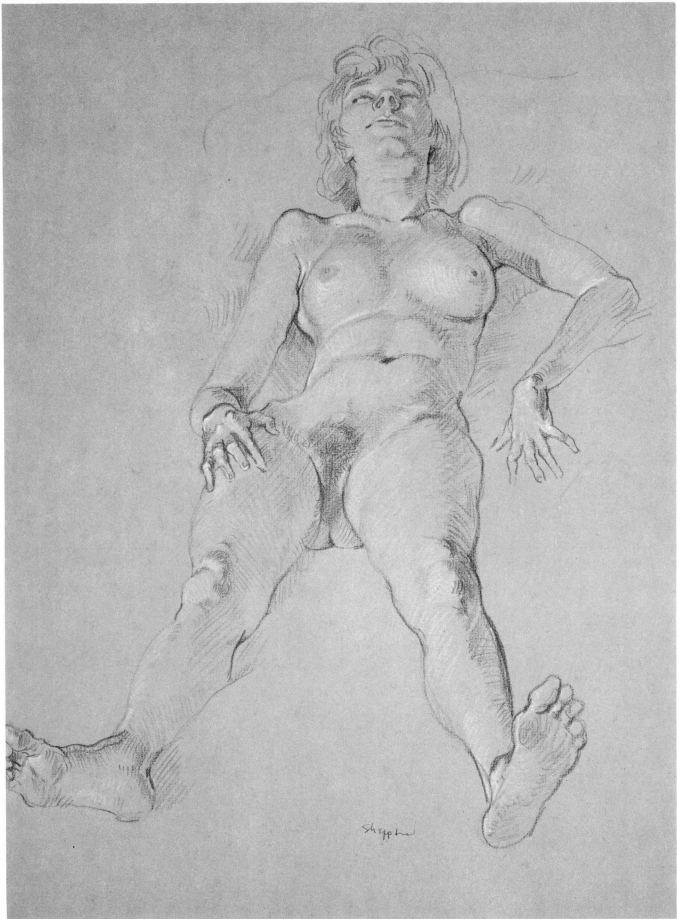

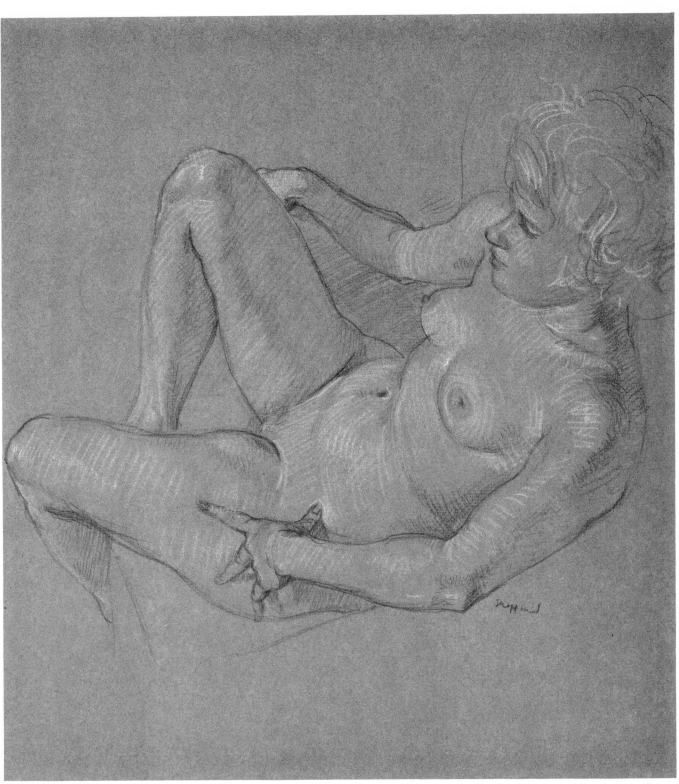

Left: Drawing the figure looking up or looking down is much the same. Suggestion of background makes the difference, along with the gravity pull of the soft, fleshy parts of the figure. Here the breasts lie aside and the stomach flattens, making the figure lie down.

Above: Looking down on a seated figure. This was drawn from the top of a ladder as a study for a painting. Unusual viewpoints can make an average pose look exciting.

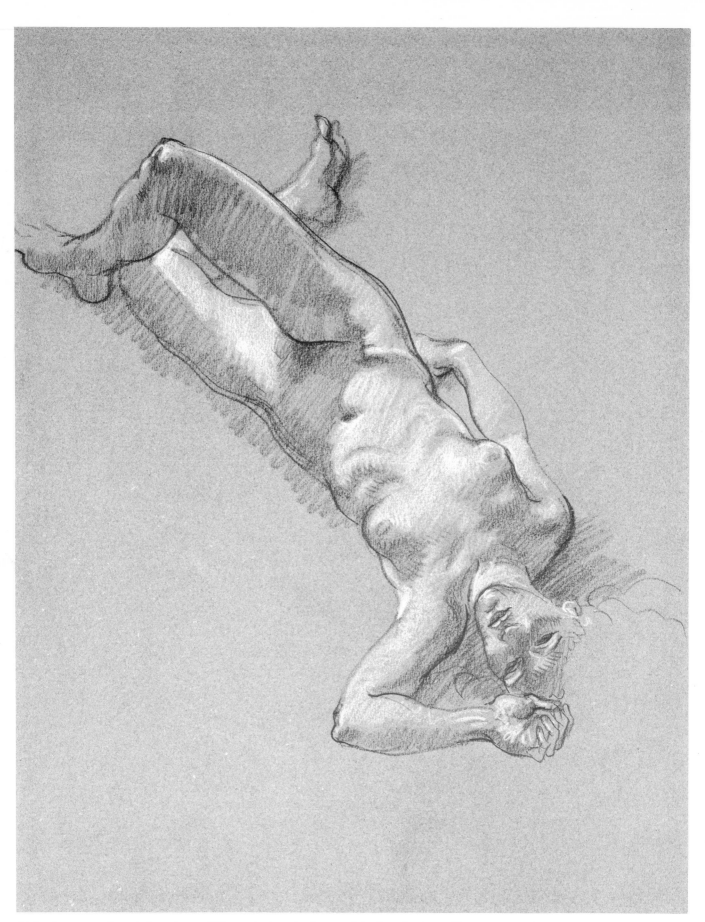

Light that comes from below gives a different look to the forms of the face, body, and breast.

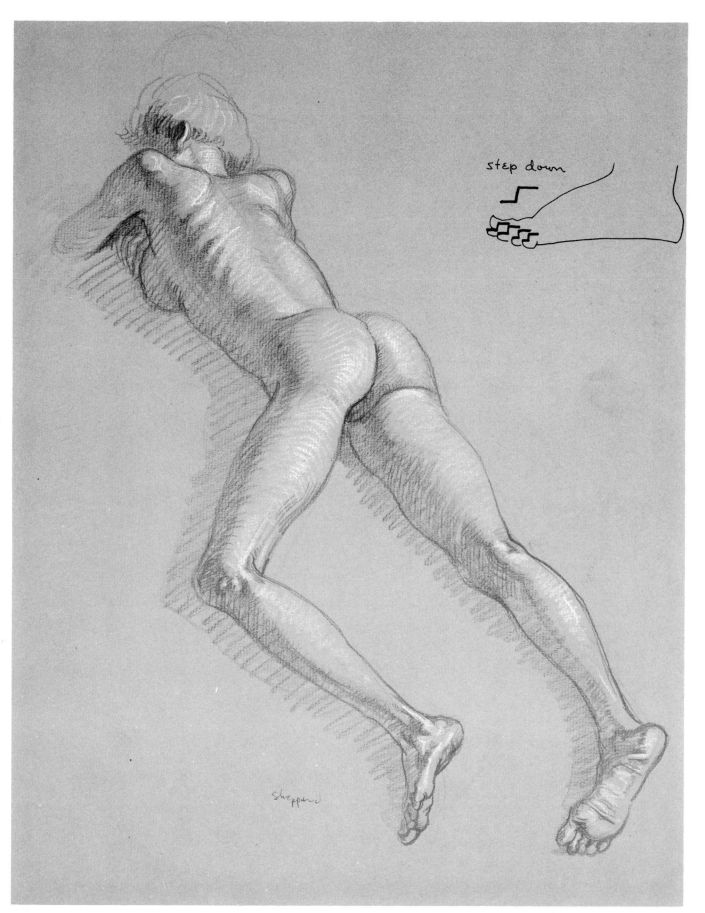

step down

The shoulderblades and ribcage are evident on this back view. The toe next to the big toe is the longest. The toes have a "stepdown" shape (see diagram).

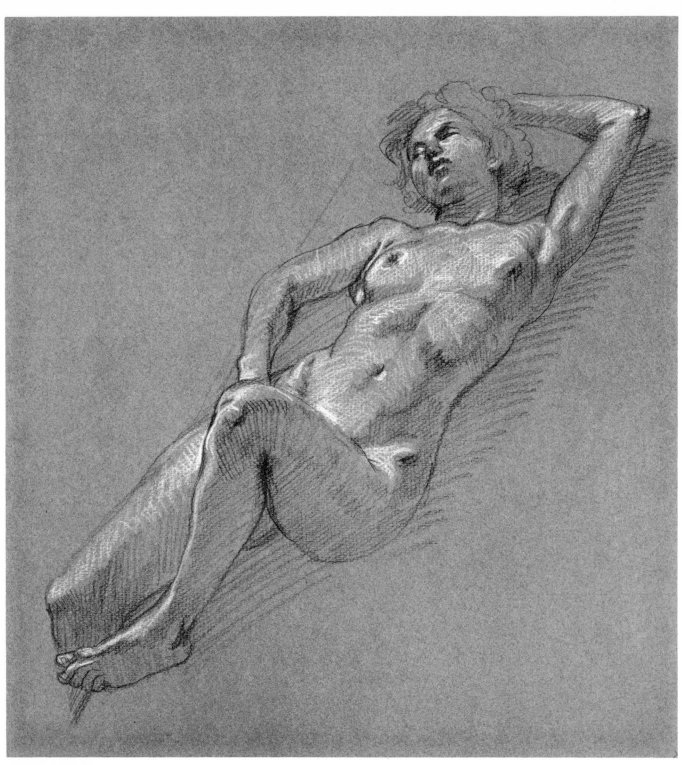

The knee is accented to bring it forward. The ribcage cavity is pronounced and the breasts flatten out.

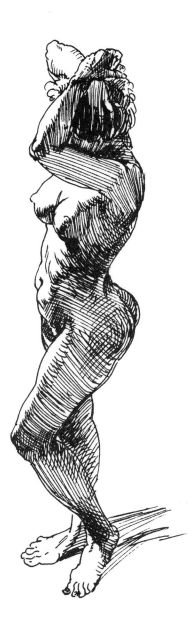

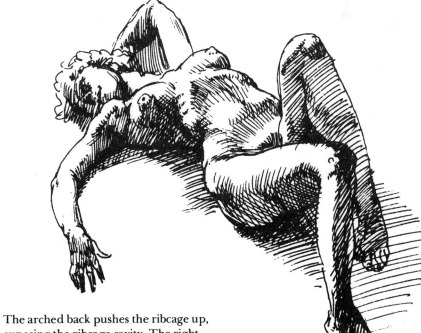

The direction of the tendon and bone above the thumb points toward the outside of the elbow (see diagram above). The part in the hair tells us the position of the head and face.

The division of the stomach muscles is evident. The line between the light and shadow becomes extremely important in explaining the form when the figure is mostly in shadow.

The arched back pushes the ribcage up, exposing the ribcage cavity. The right knee is accented by outline and intersects the right leg, bringing it forward.

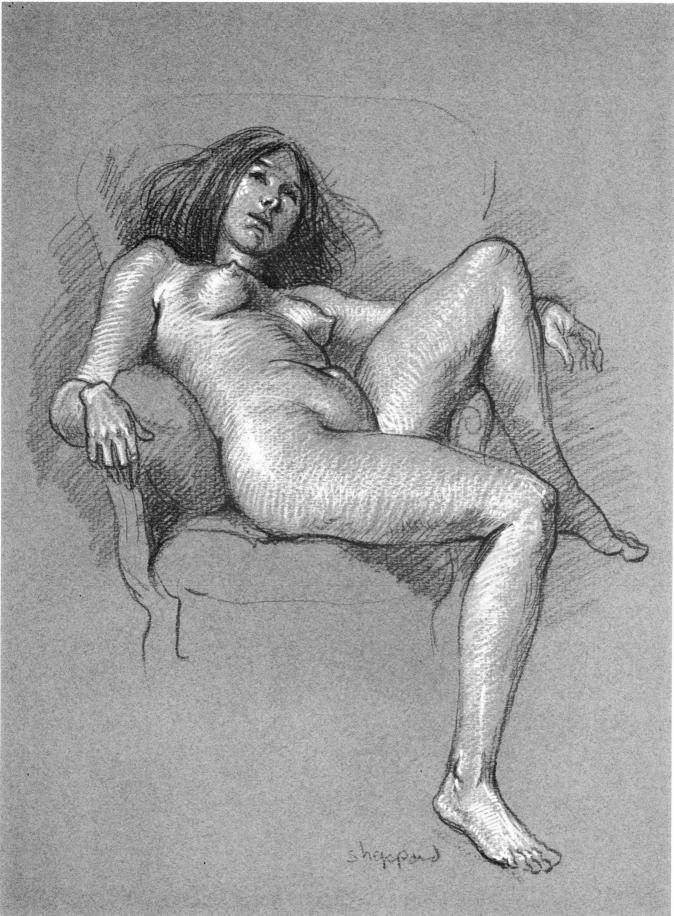

The arched back sinks into the pillow.
The breasts angle out from the middle.
The pelvis is suggested, but the fullness
of the flesh hides the ribcage.

Overlapping forms make the figure re-
cede. The buttocks cover most of the
torso, with only the shoulders showing.
The underside of the foot is drawn in
front of the ankle.

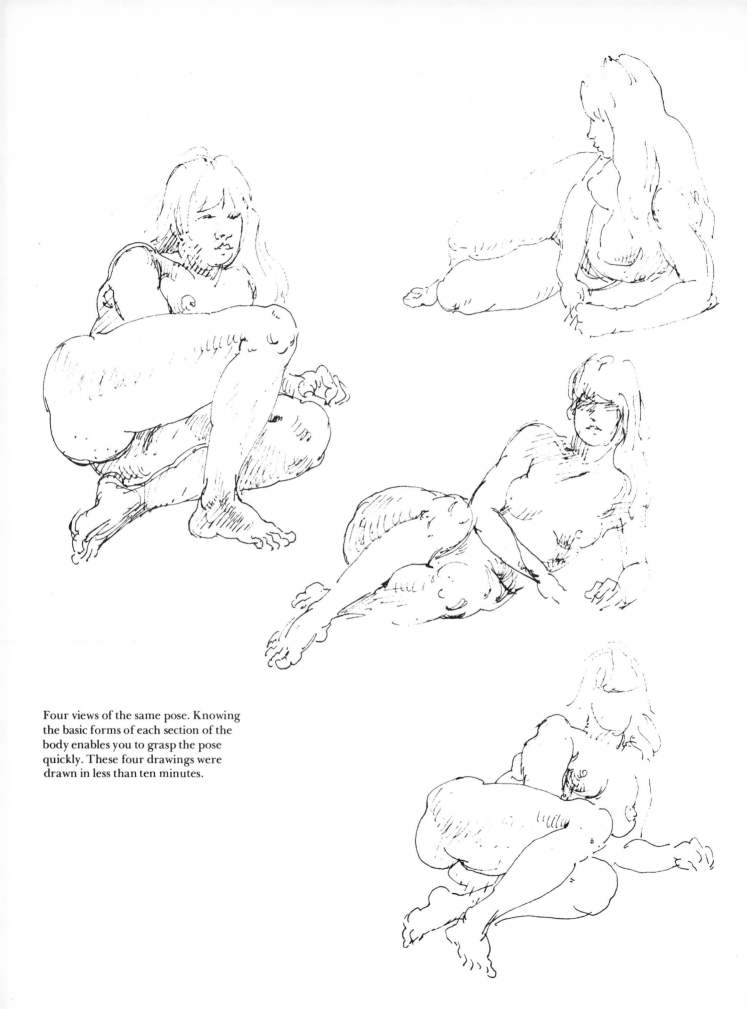

Four views of the same pose. Knowing
the basic forms of each section of the
body enables you to grasp the pose
quickly. These four drawings were
drawn in less than ten minutes.

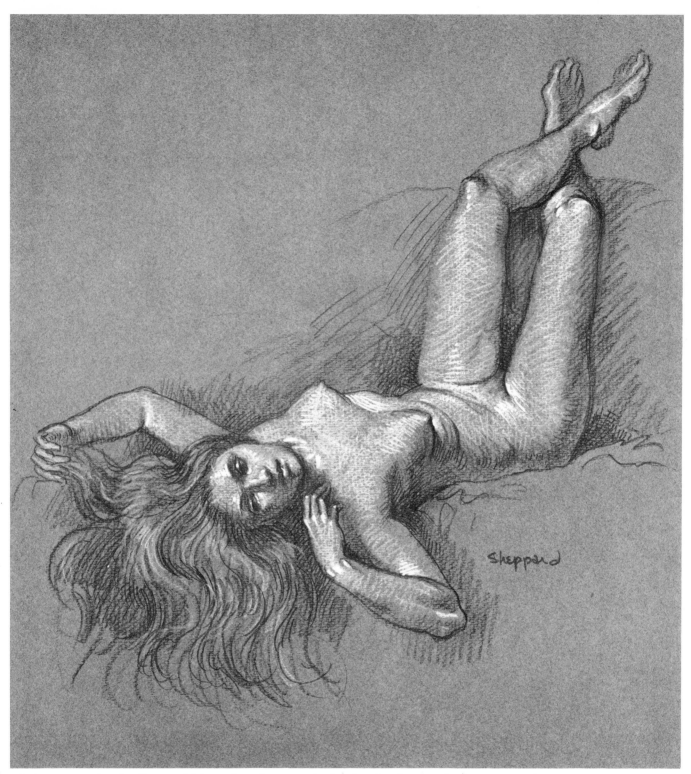

The breasts overlap the ribcage which overlaps the stomach. Overlapping forms make the torso recede.

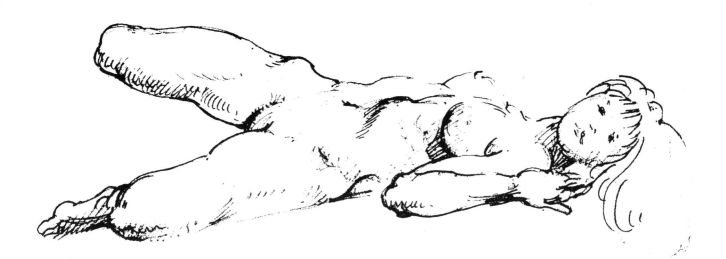

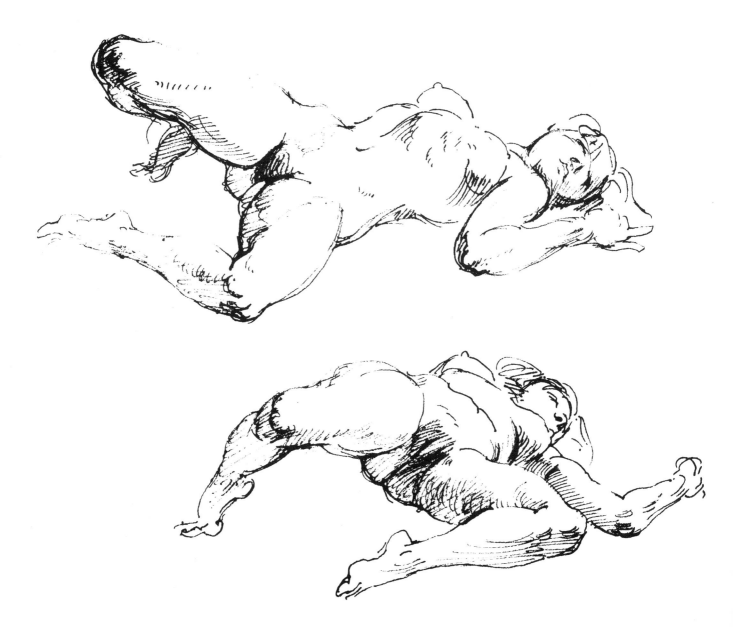

Three views of the same pose. The ribcage is pushed up by the arched backbone. The weight is on the right foot and shoulders.

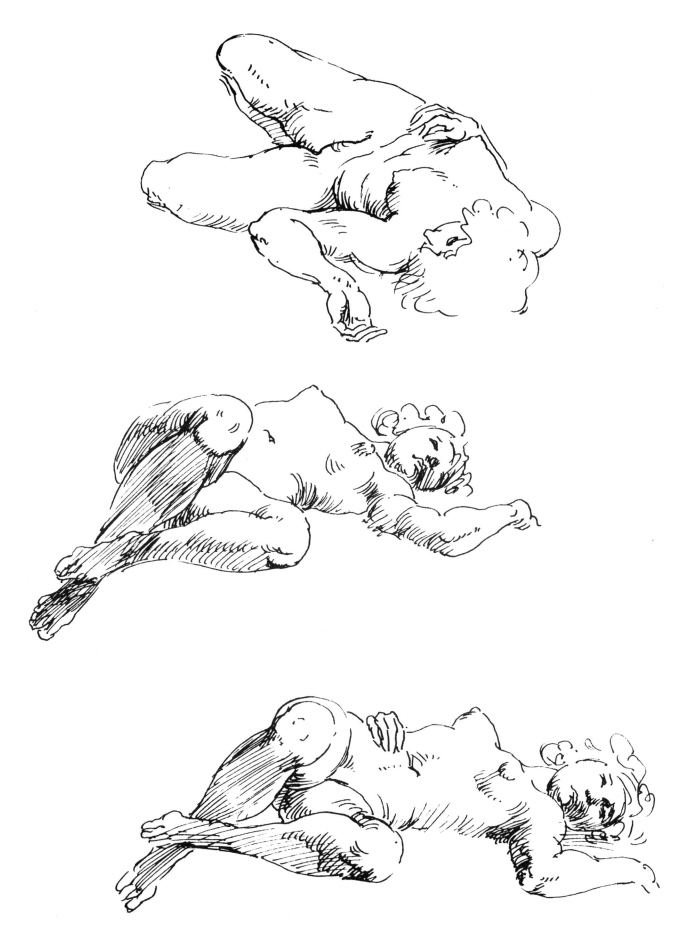

The same pose in three different views. These three drawings were made within one twenty-minute pose. The direction of the shadow lines help explain the form.

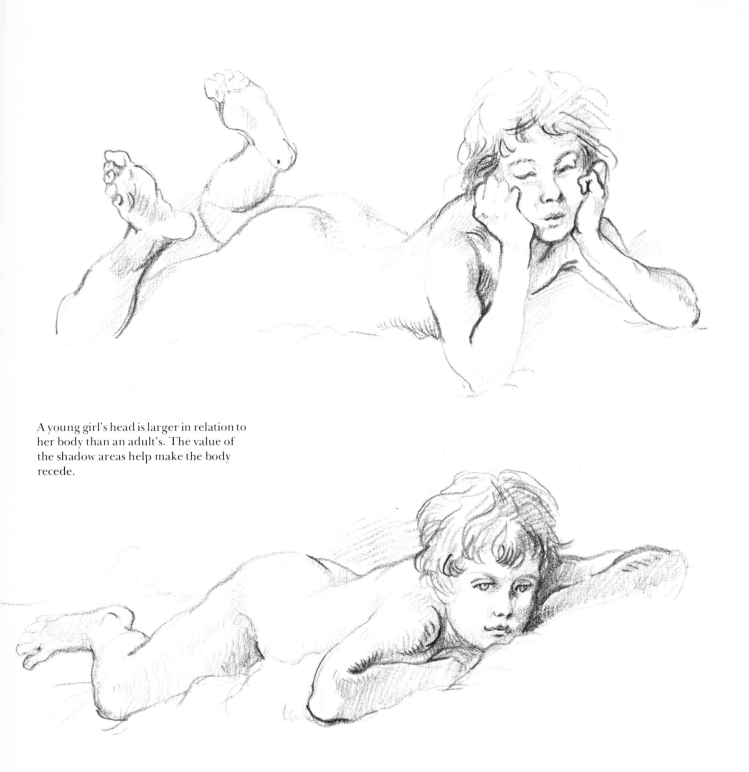

A young girl's head is larger in relation to her body than an adult's. The value of the shadow areas help make the body recede.

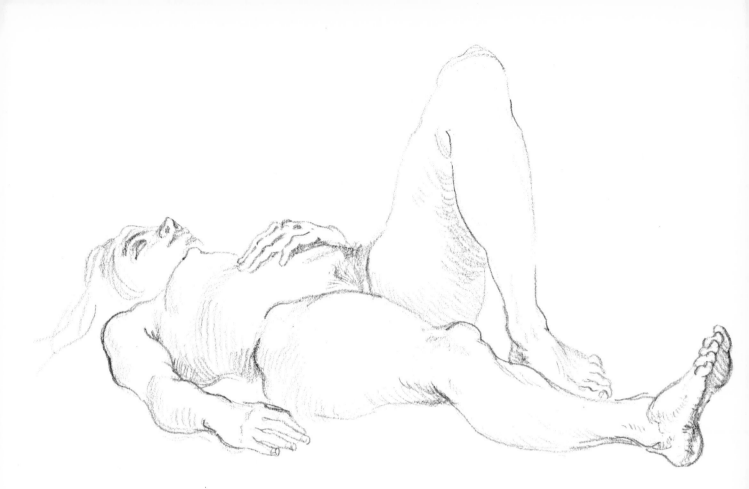

The shinbone starts under the kneecap and curves down to the inside of the ankle.
Overlapping forms again make the body and head recede.

The muscle in the back of the calf attaches above the back of the knee. The front of
the shinbone has a slight curve.

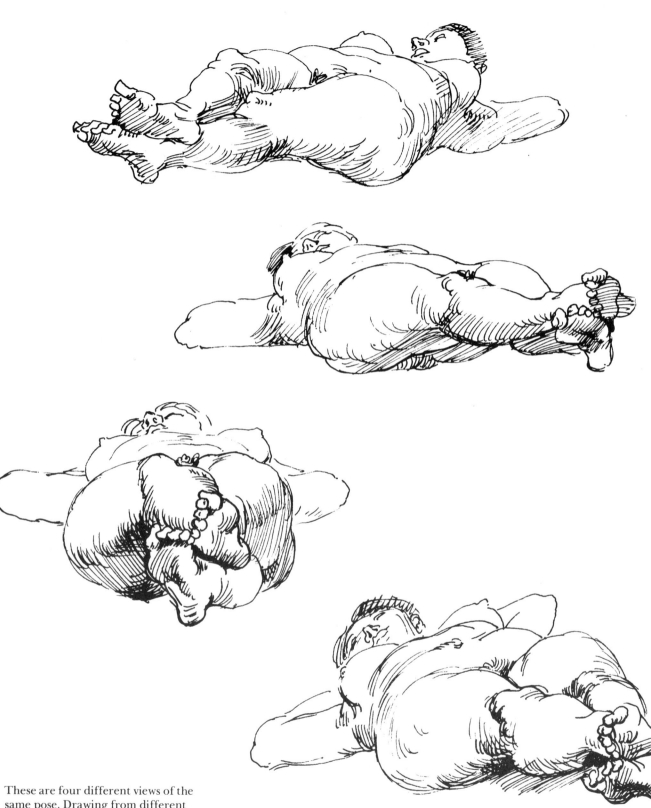

These are four different views of the
same pose. Drawing from different
viewpoints enables you to understand
the pose more fully.

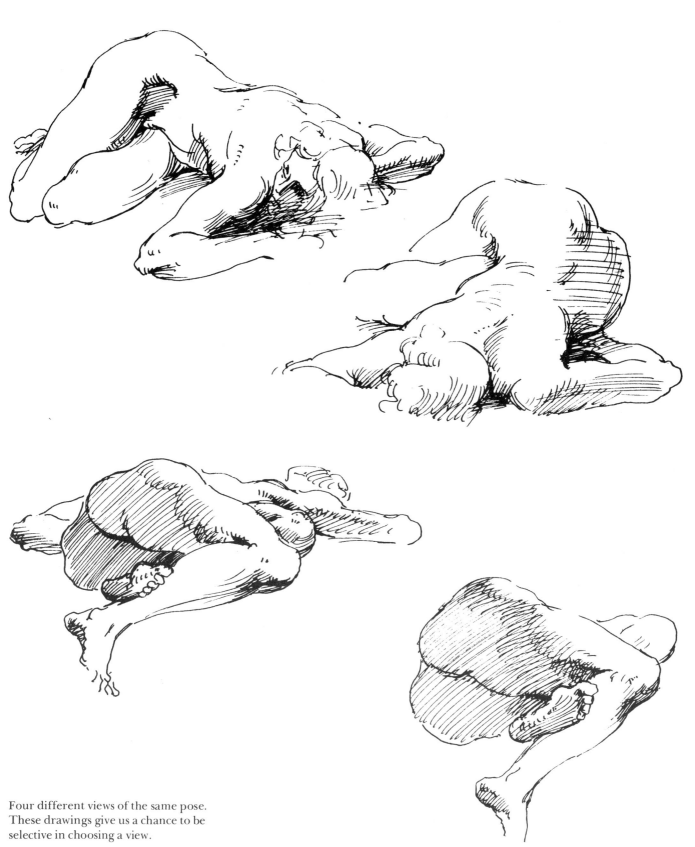

Four different views of the same pose.
These drawings give us a chance to be
selective in choosing a view.

XI
THE FIGURE IN ACTION

There are three points of action: the *preparation*, or getting ready to move; the actual *movement*; and the *followthrough*. Michelangelo's figures all seem to be either getting ready to move or just finishing. Rubens' figures are often at the height of action. When drawing the figure in the process of moving, it is important to throw it off-balance. David failed to realize this, and his figures that were meant to be in violent action stand still in studio poses. It is important to keep an action drawing free and not overrendered.

Drawing a quick pose or a figure in action should be done with the same procedure as a longer pose. Again, the first step is to find the key line and the attitude.

Shadow accent has already been stated, explaining the pelvis and ribcage.

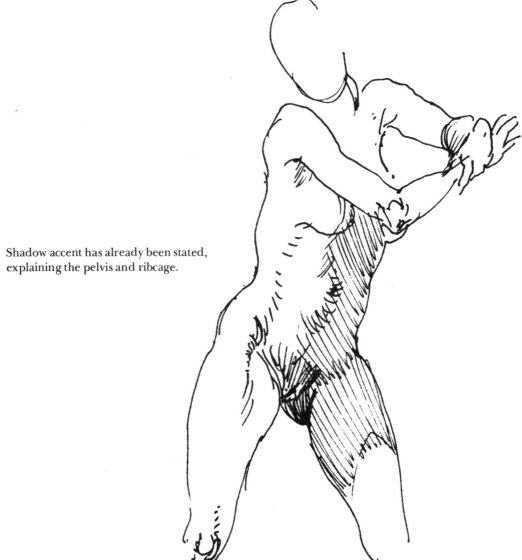

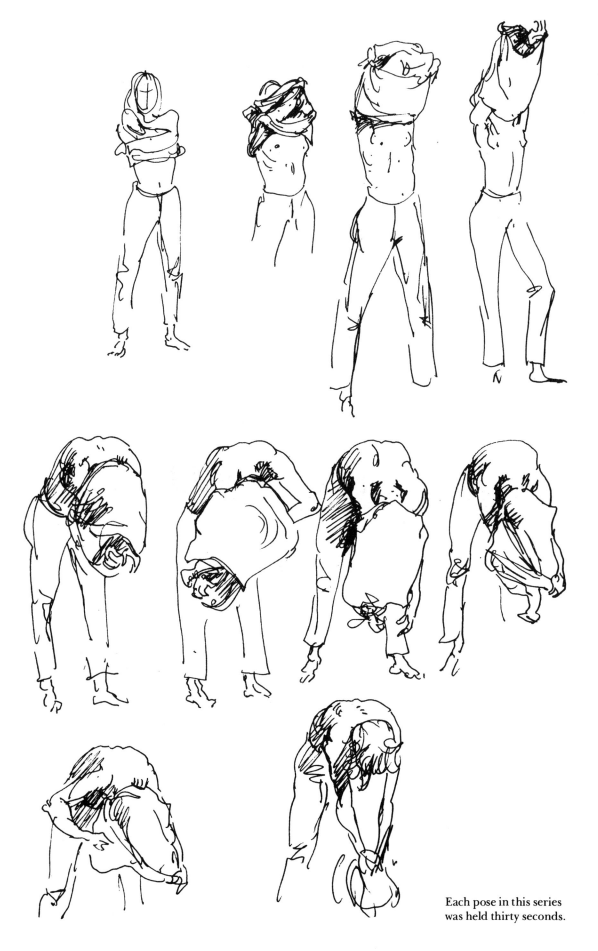

Each pose in this series
was held thirty seconds.

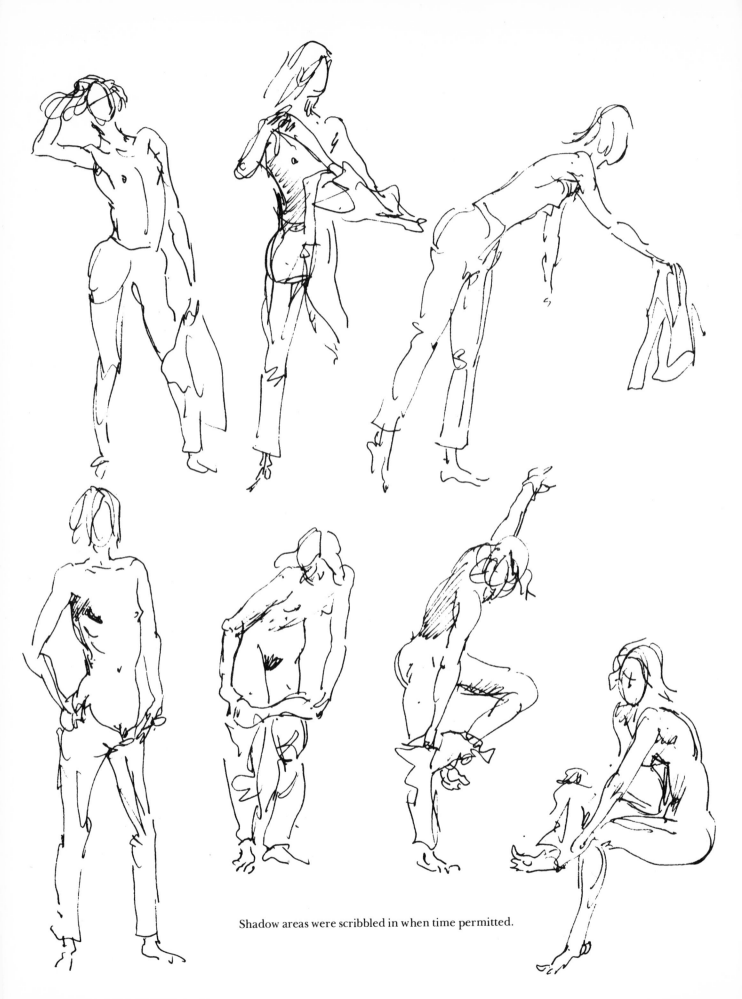

Shadow areas were scribbled in when time permitted.

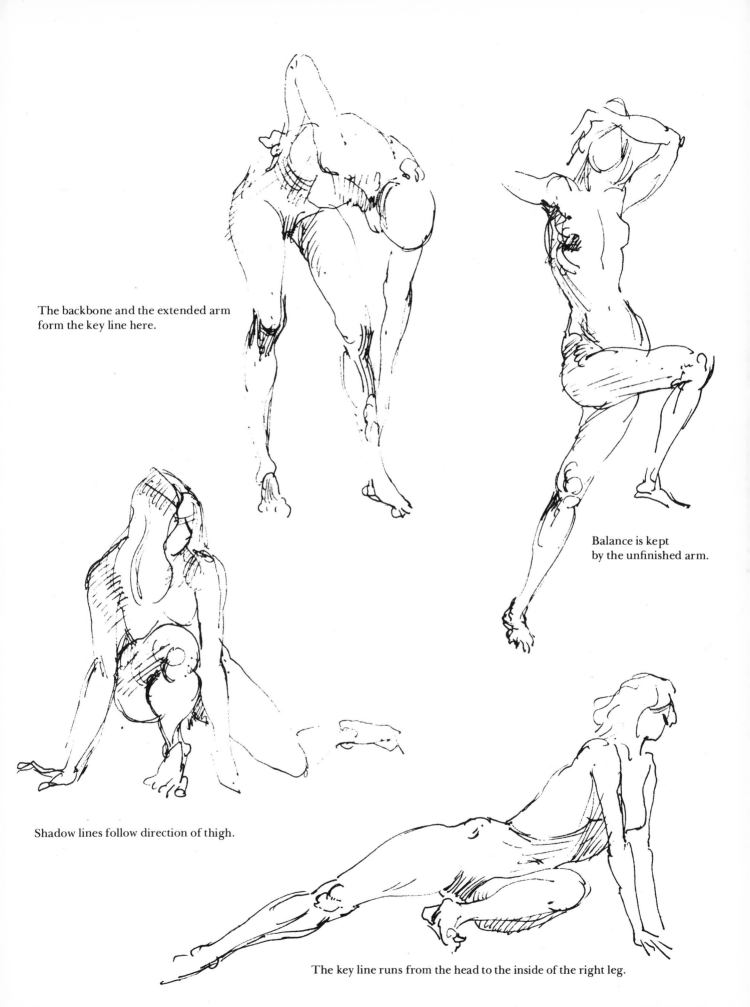

The backbone and the extended arm form the key line here.

Balance is kept by the unfinished arm.

Shadow lines follow direction of thigh.

The key line runs from the head to the inside of the right leg.

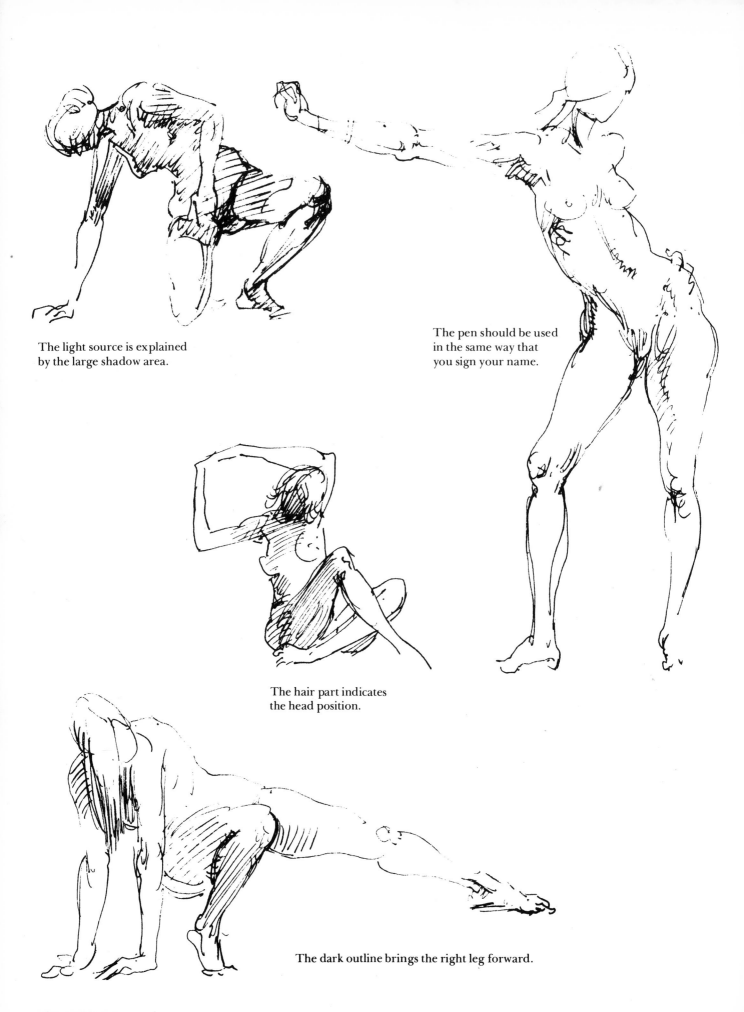

The light source is explained by the large shadow area.

The pen should be used in the same way that you sign your name.

The hair part indicates the head position.

The dark outline brings the right leg forward.

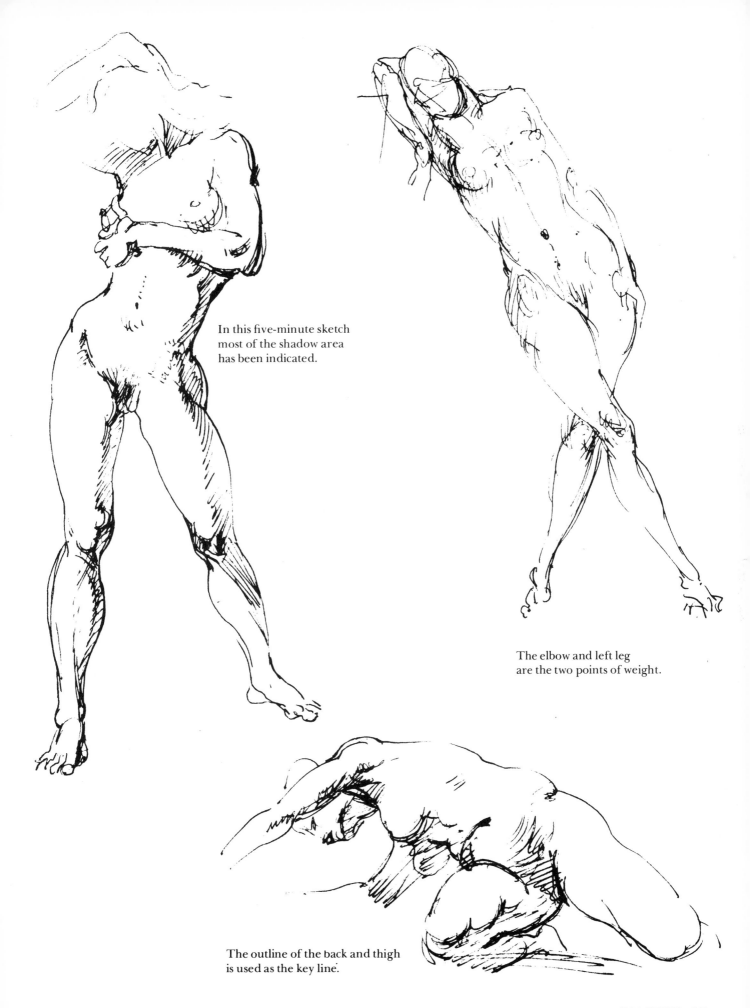

In this five-minute sketch most of the shadow area has been indicated.

The elbow and left leg are the two points of weight.

The outline of the back and thigh is used as the key line.

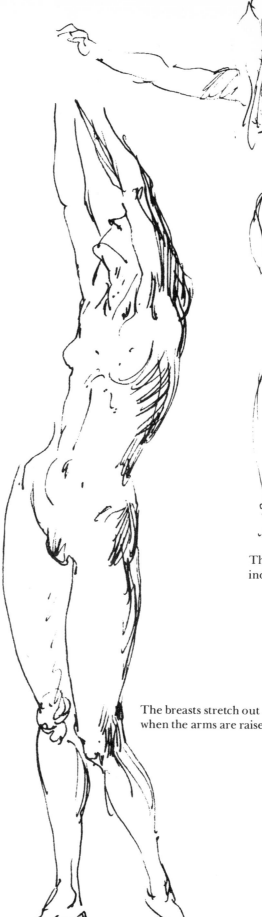

Intersecting outlines suggest form.

The *T* shape for the face
indicates the angle of the head.

The breasts stretch out
when the arms are raised.

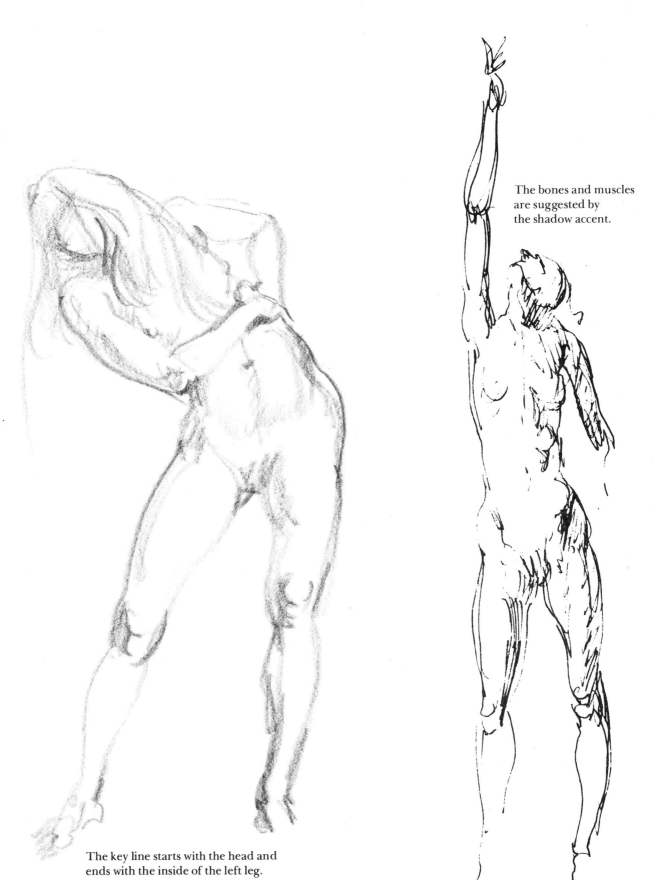

The bones and muscles
are suggested by
the shadow accent.

The key line starts with the head and
ends with the inside of the left leg.

BACK VIEW

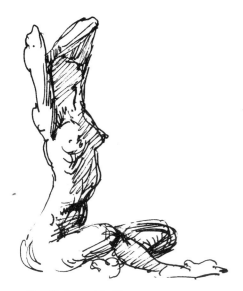

Half light and half shadow
gives the model solid form.

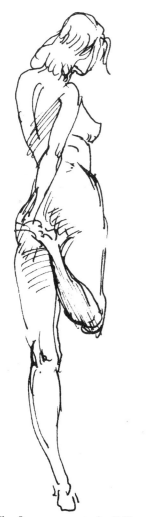

The figure seems to be falling over,
suggesting that she is being held up
by the unseen arm.

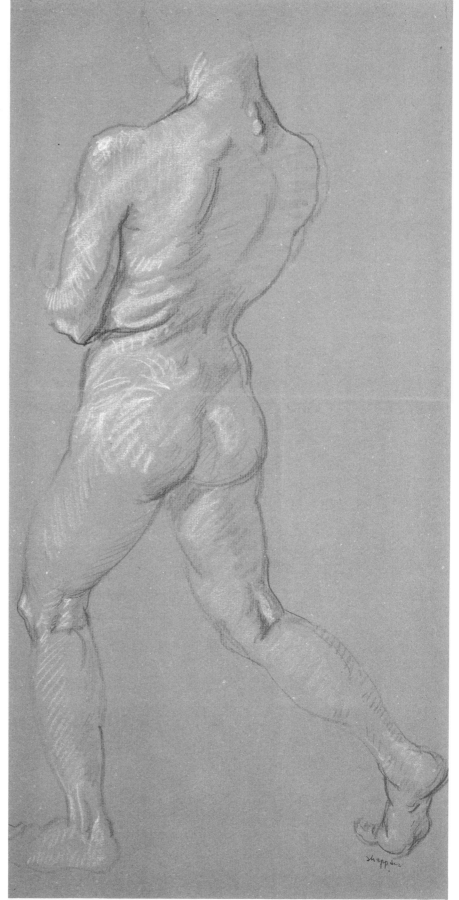

Folds at the waist help explain the action. Figure is carrying a heavy object.

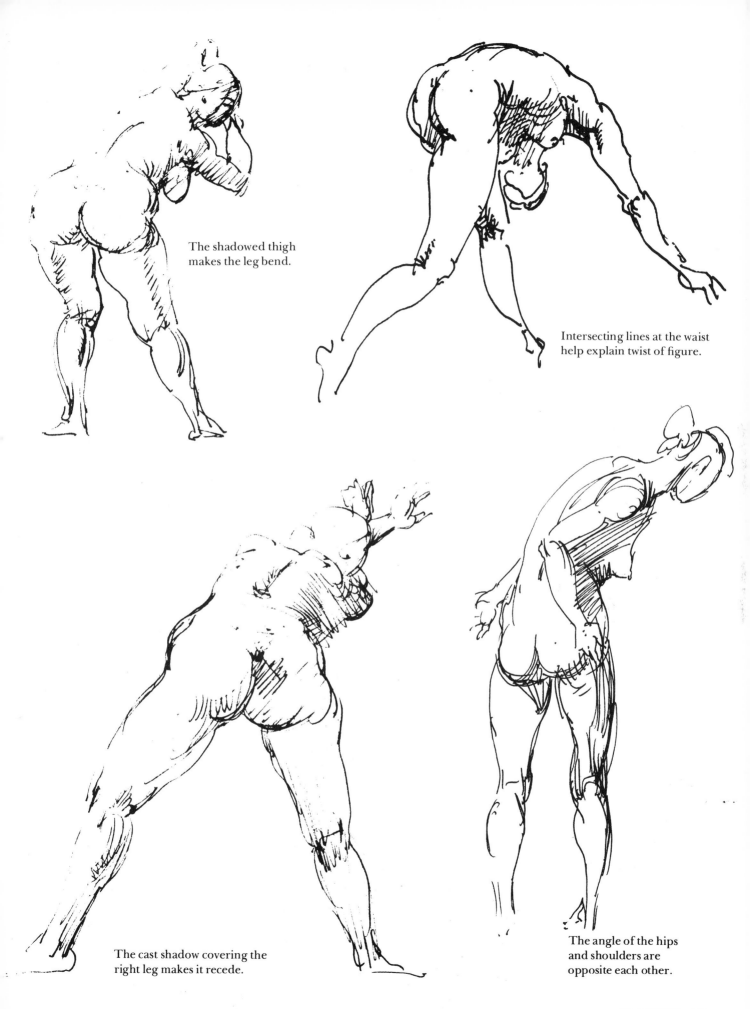

The shadowed thigh makes the leg bend.

Intersecting lines at the waist help explain twist of figure.

The cast shadow covering the right leg makes it recede.

The angle of the hips and shoulders are opposite each other.

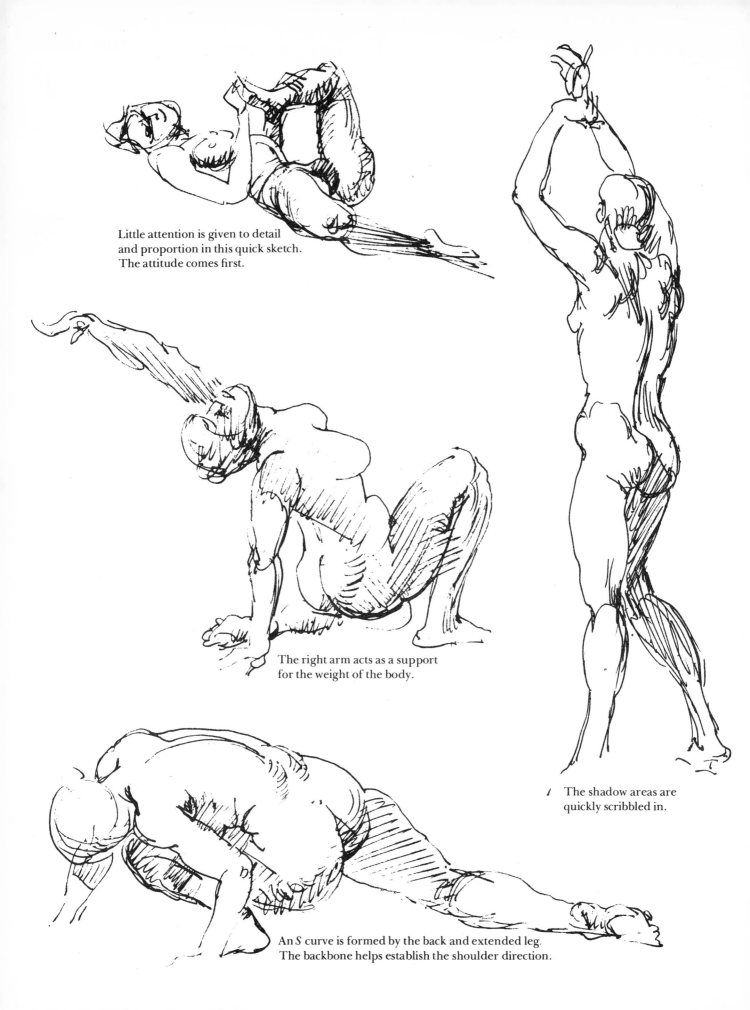

Little attention is given to detail
and proportion in this quick sketch.
The attitude comes first.

The right arm acts as a support
for the weight of the body.

The shadow areas are
quickly scribbled in.

An *S* curve is formed by the back and extended leg.
The backbone helps establish the shoulder direction.

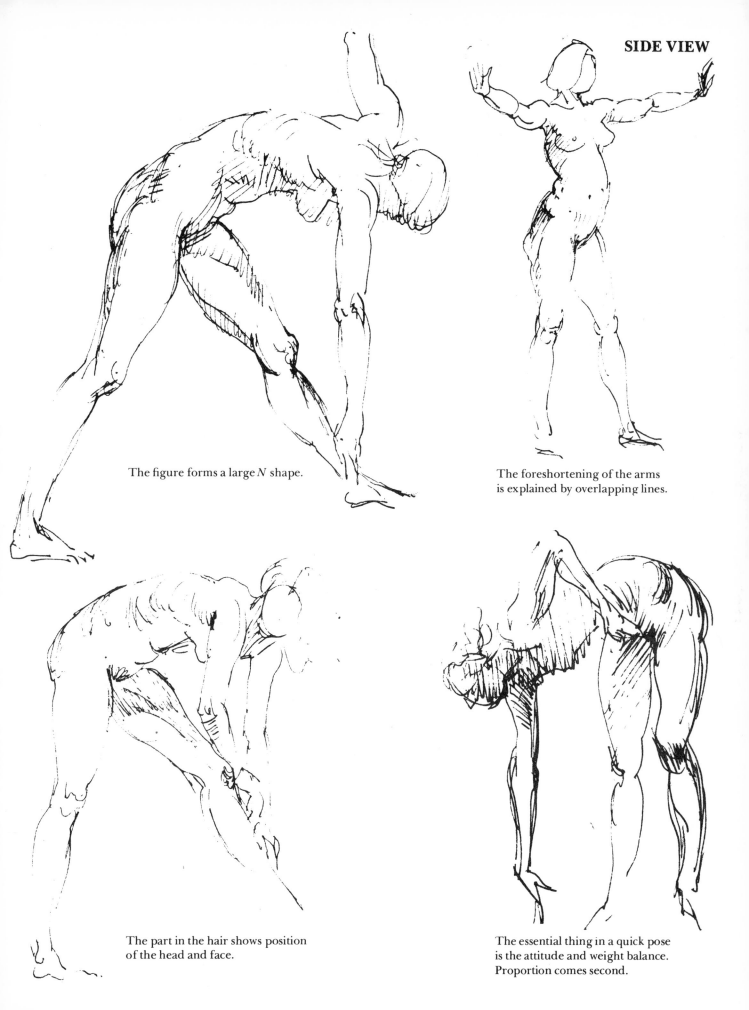

The figure forms a large *N* shape.

The foreshortening of the arms is explained by overlapping lines.

The part in the hair shows position of the head and face.

The essential thing in a quick pose is the attitude and weight balance. Proportion comes second.

IN ACTION 155

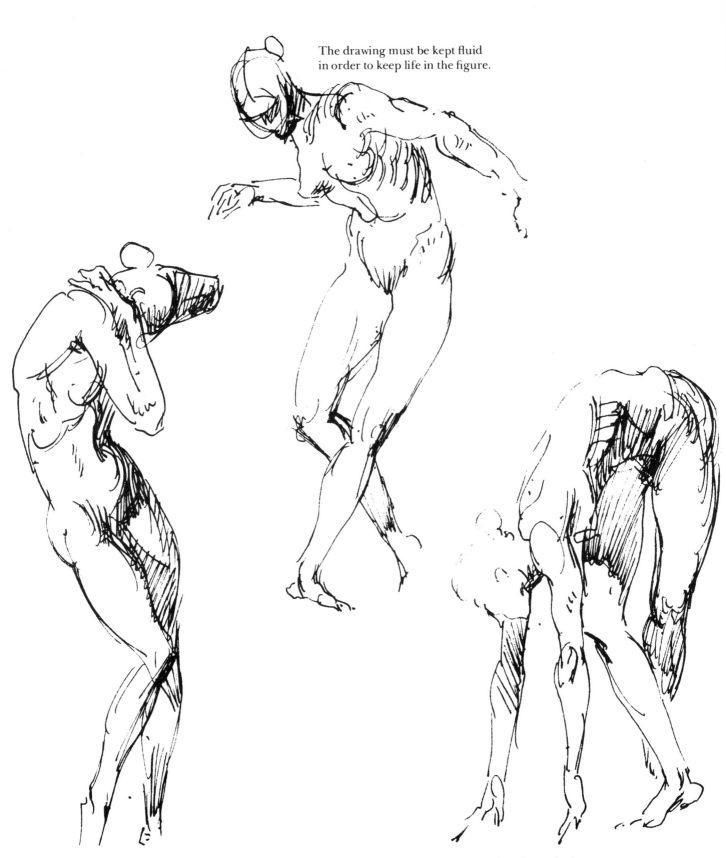

The drawing must be kept fluid
in order to keep life in the figure.

A continuous *S* curve
runs from the head
down to the ankle.

The schematic shapes
aid in drawing quickly.
Note the pelvis, ribs,
and the shapes in the arm.

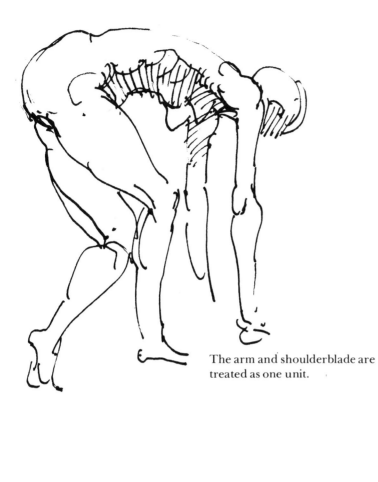

The arm and shoulderblade are
treated as one unit.

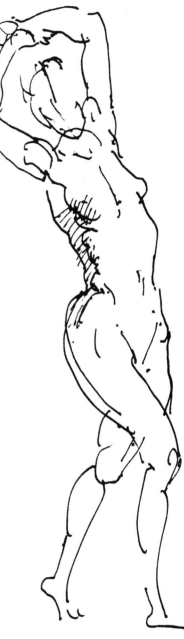

The form is indicated
almost entirely by outline.

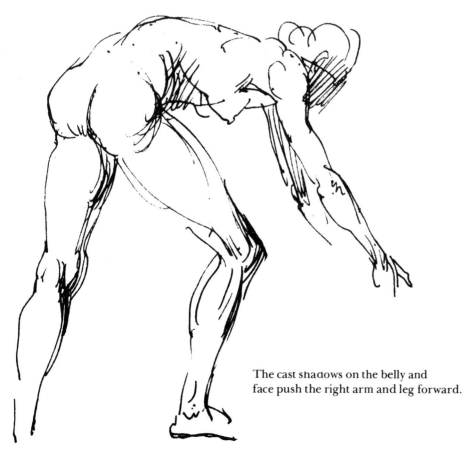

The cast shadows on the belly and
face push the right arm and leg forward.

SUGGESTED READING

Goldscheider, Ludwig. *Michelangelo Drawings*. 2nd ed. New York and London: Phaidon Press, 1966.

Held, Julius S. *Rubens: Selected Drawings*. 2 vols. New York and London: Phaidon Press, 1959.

Judson, J. Richard. *Drawing of Jacob DeGheyn II*. New York: Grossman, 1973.

Rearick, J.C. *The Drawings of Pontormo*. Harvard University Press.

Richer, Paul. *Artistic Anatomy*. Trans. and ed. by Robert Beverly Hale. New York: Watson-Guptill Publications, 1971. London: Pitman Publishing, 1973.

Sheppard, Joseph. *Anatomy: A Complete Guide for Artists*. New York: Watson-Guptill Publications, and London: Pitman Publishing, 1975.

Edited by Margit Malmstrom
Designed by Bob Fillie
Set in 11 point Baskerville by Harold Black Inc.
Printed and bound by Interstate Book Manufacturers, Inc.

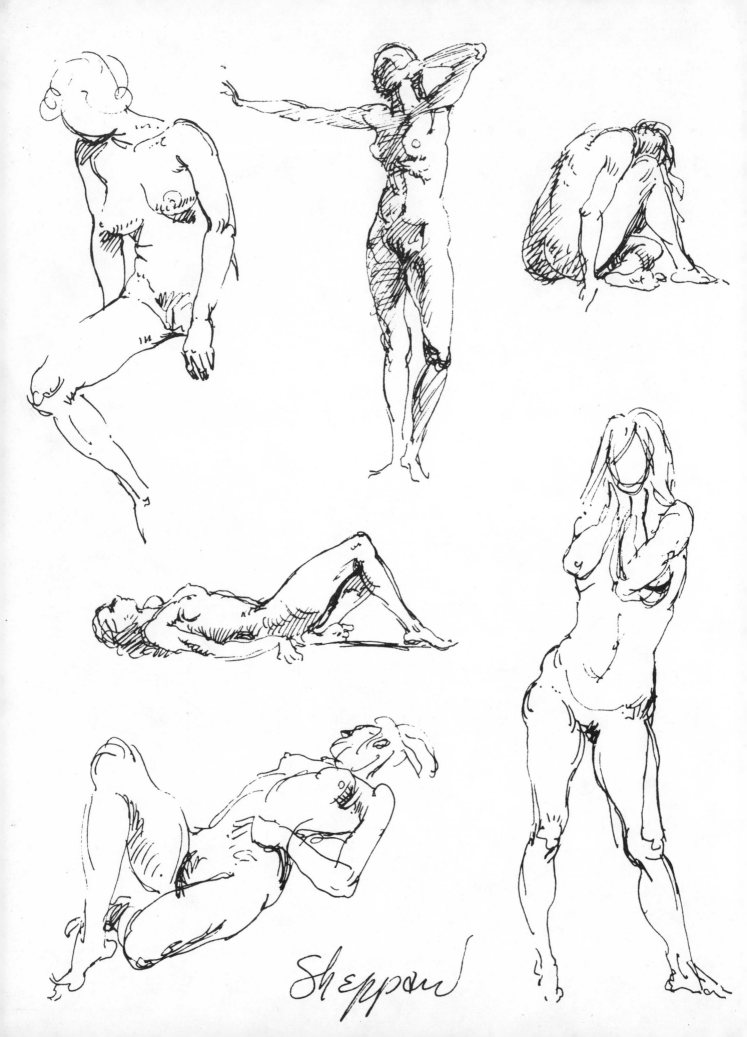

Sheppard